ADVENTURE CATS

LIVING NINE LIVES TO THE FULLEST

Laura J. Moss

WORKMAN PUBLISHING • NEW YORK

Library of Congress Cataloging-in-Publication Data is available.

ISBN 978-0-7611-9356-2

Design by Janet Vicario
Layout by Ariana Abud
Cover photo: Cat © Karen Nguyen; Mountain background © Thomas Pozzo di Borgo
Photos © Craig Armstrong: pp. 105, 106–107, 108, 109. Photos © Michael Anderson and Alyse Avery: pp. 54, 99 (top and middle), 100–101. Photos © Tomiina Campbell: pp. 131, 132–133, 134, 135, 136, 137. Photos © Patrick Corr: pp. 73, 79, 205, 206, 207. Photos © Johanna C. Dominguez: p. 161. Photos © Susie Floros: pp. 3, 65, 66–67, 69, 85. Photos © Alex Gomez and Krista Littleton: pp. 5, 139, 147, 148, 149. Photos © Emily Grant: pp. 15, 17, 18–19, 20, 21, 43, 97, 118, 127 (top), 141, 153, 214. Photos © Martin Henrion: pp. 201, 203. Photos © Cees and Madison Hofman: pp. 7, 23, 24–25, 26, 31, 48, 52, 95, 119, 142, 144, 163. Photos © Matt and Jessica Johnson: pp. 150, 155, 156–157, 158, 159. Photos © Carole Lacasse: pp. 193, 194. Photos © Nathalia Valderrama Méndez: pp. 32, 49, 56, 84, 93, 126, 129, 140, 173. Photo © Karen Nguyen: p. 128. Photos © Anna Norris: pp. 11, 51, 89 (top), 102 (bottom), 103. Photos © Kim Randolph: pp. 175, 176, 177, 178–179. Photos © Andrea Rice: pp. 185, 189 (bottom). Photos © Kristy Schilling: pp. 111, 112, 113. Photos © Graham and Erin Shuee: pp. 121, 122 (top), 123, 124–125, 127 (bottom). Photos © Jennifer Stokes: pp. 145, 198, 199. Photos © Aina Stormo: pp. 162 (left), 165, 166–167, 168, 169. Photos © Lacy Taylor: pp. 202, 209, 210, 212, 213. Photos © Kayleen VanderRee: pp. 12, 59, 60–61, 62, 63, 116. Photos © Cody Wellons: pp. 1, 8, 27, 29, 34, 36, 38, 39, 41, 68, 75, 80, 82, 83, 89 (bottom), 90, 99 (bottom), 102 (top), 115, 122 (bottom), 128, 162 (right), 171, 182, 183, 184, 185, 187, 188, 189 (top), 190, 195, 197. Photo © Heather York: p. 181.

Workman books are available at special discounts when purchased in bulk for premiums and sales promotions as well as for fund-raising or educational use. Special editions or book excerpts also can be created to specification. For details, contact the Special Sales Director at the address below, or send an email to specialmarkets@workman.com.

Workman Publishing Co., Inc.
225 Varick Street
New York, NY 10014-4381
workman.com

WORKMAN is a registered trademark of Workman Publishing Co., Inc.

Printed in China
First printing April 2017

10 9 8 7 6 5 4 3 2 1

6/2017

To AN OLD CAT LOVER FROM A
RECENTLY NEW CAT LOVER..... THANKS
FOR SHOWING ME THE WAY!

Love,
Mark

*This one's for all the adventurers
on this beautiful planet
and for everyone who's ever known
the love of a cat.*

Contents

INTRODUCTION

>»»»‹‹‹‹‹‹

THE *ADVENTURE CATS* STORY

T he first time I saw a cat on a leash was when I was volunteering for a cat rescue in college. On Saturday mornings, I'd drive to a local pet store to help empty litter boxes, scrub crusty food dishes, and play with all the adoptable kittens that neither my mother nor my resident adviser would allow me to bring home. But one morning when I arrived to perform my regular duties, there was a note on one of the cages instructing me to take the orange tabby on a walk through the store. A tiny blue harness dangled beside the cage.

Take a cat for a walk? While I'd seen plenty of leashed dogs wander through the aisles of the store, I'd never once encountered a leashed cat. I didn't even know you could walk a cat. After all, cats seemed like the kind of animals that would be above that sort of thing. Being led around by a mere human? Leave that to the dogs.

But once the cages and dishes gleamed and the litter boxes were freshly refilled, I let the skinny cat out and—much to my surprise— easily snapped on the harness. Then we were off. The little ginger knew right where he wanted to go and didn't let curious onlookers or snarling schnauzers distract him from the journey at hand. He made his way straight to the aisles devoted to cat food and treats and set to work sniffing and exploring. Eventually, he climbed atop a cat tree.

"How did you train him to walk on a leash?" people asked me. "Do they sell cat harnesses here?" others inquired. "I don't know," I replied again and again. A cat on a leash? It was new to me too.

For most people, the sight of a cat on a leash is quite surprising.

The next Saturday, I was looking forward to taking that cat on another walk through the store, but when I arrived, a new feline had taken his place. The little leash-trained tabby had been adopted. Apparently, someone had seen him prowling through the aisles on his harness and filled out an adoption application that very day.

Despite the impression that cat made, I didn't attempt to leash train any of my own cats for another decade. It wasn't until I started hearing about courageous kitties like Millie the climbing cat (see page 104) that I started to wonder about the possibilities of adventuring with a cat. And it wasn't until one of my own cats—once so content to watch the outside world from the window—suddenly darted out the door that I actually purchased a couple of cat harnesses.

I leash trained both of my cats and slowly introduced them to the world beyond the windows. And as they became more comfortable exploring the wilds of the backyard, my husband and I, who are both active hikers, started to wonder if our kitty companions might one day safely join us on a trail. So I did what anyone looking for information would do: I Googled it. I found plenty of articles and blog posts about leash training cats, but none of them explained how exactly a cat could go from exploring the backyard to hiking and camping alongside its owners. So in March 2015, when I told my husband how the Internet had failed to provide me with the one-stop resource my outdoorsy, cat-loving heart desired, he said, "You could make that." With that statement, AdventureCats.org began to take shape in my mind, but what started out as an idea for a simple online resource for fellow adventure cat enthusiasts soon evolved into much more.

You see, I'd recently pitched a story to my editor about stereotypical "cat people." I expected the article to be an entertaining look at how modern women defy the absurd and surely obsolete stereotypes associated with owning cats, but the story took an unexpected turn when my research revealed that people

Brave felines like Floyd (see page 64) prove that not all cats are content to spend their lives indoors, especially when their owner has a cozy backpack.

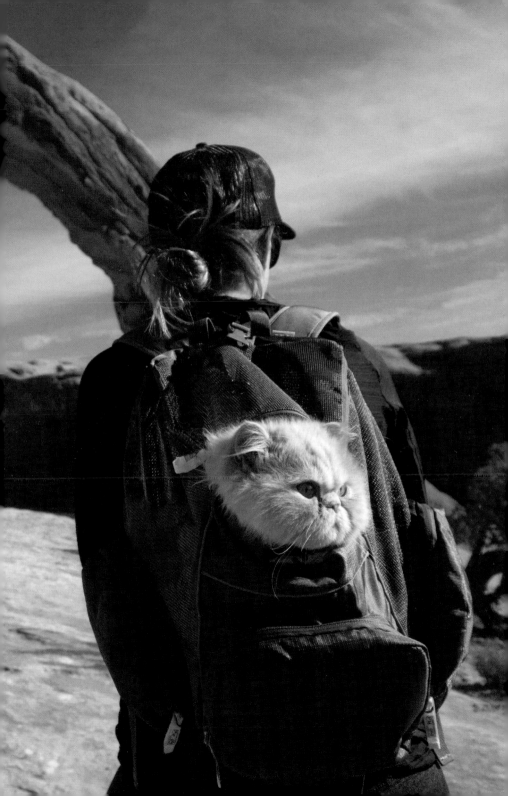

really do buy into the "crazy cat lady" persona. In fact, 49 percent of Americans believe it's an accurate stereotype, according to a 2015 PetSmart Charities survey. And when asked which qualities they associated with cats, a majority of people assigned such words as *moody, stubborn,* and *aloof.*

As I did more research, I talked to women who said they wouldn't adopt another cat for fear they'd be labeled a "crazy cat lady." I came across men who said they'd been mocked for having cats, which are thought by most to be "pets for women." I even read blog posts written by women explaining that a single man with a cat is a red flag, as well as "confessions" penned by men defending their love of cats, as if there were something inherently emasculating about providing a loving home for a feline.

Are these negative perceptions about cats and their owners actually hurting adoption rates? I wondered. I talked to shelter workers who said they believed so, but perhaps the numbers best speak for themselves: According to that same PetSmart Charities survey, 19 percent of respondents said there simply aren't as many adoptable cats in shelters as there are dogs, but in reality, more cats—1.4 million annually, according to the American Society for the Prevention of Cruelty to Animals (ASPCA)—are euthanized in U.S. shelters than dogs. And a 2014 U.S. Shelter Pet Report found that 27 percent of people considering a new pet said they wouldn't adopt a cat. Apparently, our perceptions of cats and the people who love them really can play a role in shelter adoptions.

So it was in researching a story completely unrelated to AdventureCats.org that I found the most pressing reason to build the site. Yes, I wanted to create an informational resource, but even more than that, I wanted to change people's minds about what it means to be a cat person. I wanted them to see that while cats can make excellent company for single women, they can also make "pawsome" outdoor companions for men and women alike. After

all, if there's one lesson that little orange tabby at the shelter taught me, it's this: A cat that defies stereotypes is a cat people want to talk about and a cat that finds a home. By challenging ideas of what cats and the people who love them are like, I hope that more people will be inspired to take home one of those millions of homeless kitties—and maybe even take them on an adventure.

WHY ADVENTURE WITH A CAT?

One of the many things people love about cats is how they remind us to slow down. With their soothing purrs and fondness for snuggling, our feline friends can be a comforting presence in our homes—not to mention the purrfect companions for a Netflix marathon. It may seem out of character or even downright strange to bring a cat on a nature hike or canoe trip, but for many adventure cat owners, taking the cat along was always part of the plan. "For me, it was just assumed that any animal I owned would accompany me surfing. I spend the majority of my time on the water, and I just never gave it a second thought," said Alex Gomez, a special-education teacher in Hawaii who surfs with her cat, Nanakuli.

For other cat owners, the inclusion of their feline friends in outdoor excursions evolved naturally. "One of my main outlets is to do anything outside and active, but I found myself feeling guilty for leaving my cat, Josie, to go hike or camp when I had the occasional free weekend," said University of Tennessee veterinary student

Nanakuli hangs ten in Hawaii (see page 146).

Erin Dush. "Several classmates jokingly said that I should just take her with me, so I decided to give it a try. She took to hiking immediately, and from there I've just continued to try her in any activity that dogs tend to enjoy."

However, adventuring with a cat isn't always about integrating a pet into an already active lifestyle. Often, the decision to leash train is made because it's good for the cat. Just as our waistlines are expanding, so are those of our pets. A 2014 survey by the Association for Pet Obesity Prevention found that nearly 60 percent of U.S. cats are overweight or obese. If your kitty is part of that percentage, then he may benefit from a little more exercise, and leash walking can be a fun way for you both to be more active.

In addition to encouraging physical activity, venturing outside on a leash also provides mental stimulation for cats, which can help with boredom-related behavioral issues. Because while we may think of our kitties as snuggly little house pets, the truth is they're actually not that far removed from their wild ancestors. Researchers at the McDonnell Genome Institute at Washington University found that as few as thirteen genes may separate domestic cats from wild cats, so it makes sense that many cats enjoy being outside, investigating new sights and sounds, and lazing in the sun. "Too little stimulation causes frustration, stress, boredom, and depression," said veterinarian Dr. Frank McMillan, director of animal well-being studies at Best Friends Animal Society. "This state of psychological deprivation is a common cause of unwanted behavior—such as urinating

> "If you could ask your cat every morning when you both wake up what he or she looks forward to that day, it's often difficult to think of what the indoor-only cat might say," said Dr. McMillan. "But it's easy to imagine the response of the cat who goes outside on a harness and leash: 'Our walk! Our walk!'"

throughout the house and destructive behavior—that indicates unhappiness and lack of emotional fulfillment."

And if you need yet another reason to get outside with your cat, consider how much fun it could be for both of you if your cat takes to a leash!

However, allowing a cat to come and go from the home at will and explore the great outdoors unsupervised isn't an ideal solution. There's a reason indoor cats typically live twice as long as outdoor ones: They're not exposed to diseases, wildlife, and traffic.

Likewise, forcing a cat to live inside when he's accustomed to roaming outdoors can also backfire, as *New York Times* reporter Stephanie Clifford is well aware. "When I cut off his access to the great outdoors, my cat, usually spunky and friendly, threw himself against the door, yowled, and attacked my legs with frustration and sharp claws," she wrote in 2011. The answer? Leash walking. "Six months after I started, I have a relaxed cat, a new admiration for his pluck and agility, and, probably, a growing reputation as the weird cat lady," she said.

Speaking of being the weird cat lady (or cat man), don't let that deter you from taking your own cat into the great outdoors. While your pet may be the first leashed cat that people encounter in the neighborhood or on the trail, it certainly won't be the last. The practice is becoming much more common, and by taking Fluffy, or Sir Meows-a-Lot on a walk, you're helping bust the very stereotype you're trying to avoid. When people see you engaging with your cat in nature, you change their minds about what it means to be a cat owner—and that translates into more shelter kitties finding forever homes.

Adventure cats—and their owners—break the mold.

IS ADVENTURING RIGHT FOR YOUR KITTY?

Just as every person is different, so is every cat. You likely have friends who love hiking, camping, and spending time outdoors, but you probably also have friends who'd sooner join you for a root canal than a camping trip—and as much as you'd love for them to share some s'mores, you have to respect their wishes. The same goes for your kitty.

Each cat has a unique personality, and just as we may identify as a Myers-Briggs personality type like ENFP or ISTJ, we can also attempt to categorize felines according to their personality traits. The ASPCA defines several "feline-alities" that the organization's shelters employ to match potential adopters with the right cats for their lifestyles. The Meet Your Match Feline-ality adoption program is based on an assessment that reliably predicts how a particular cat is likely to behave when the animal is adopted into a new home. Potential adopters take a survey to reveal what they're looking for in a cat, and they're assigned one of three colors based on their results. They can then meet cats that have been assigned the same color, which means the felines would likely be a good fit for their household.

Shelters that use these personality profiles have demonstrated a 40 to 45 percent increase in adoptions and a 45 to 50 percent decrease in cat returns and euthanasia. Clearly, understanding cats'

All cats have unique personalities, just like people.

personalities can help shelters match felines with the right people, but it may also be possible to use your own cat's feline-ality to determine if she'll enjoy outdoor activities. The three categories used by the ASPCA are assigned the colors green, orange, and purple and are determined by the cat's playfulness, how the cat responds to new people and situations, and how much the cat enjoys being petted and held.

- **Green cats** are "savvy, unflappable, and adventurous."

- **Orange cats,** though not as bold as green cats, are considered "good company"—they're sociable and interested in their environment.

- **Purple cats** "seek affection, are pretty quiet, and tend to stay out of trouble."

Green and orange kitties are considered high-valiant feline-alities—meaning they tend to adapt well to new situations—and are some of the best matches for a more adventurous lifestyle. "Cats who are more valiant would likely be better candidates for finding harness opportunities rewarding," said Dr. Emily Weiss, senior director of ASPCA research and development and the creator of feline-alities. "The [green] feline-alities are the three high valiant feline-alities. In addition, the orange cats have a lower valiance score but are still adventurous cats."

Purple cats, on the other hand, are cautious and often keep to themselves, so venturing outside could be more stressful for them. Of course, there are exceptions to the rule—like an Atlanta cat named Snowflake. "Snowflake is definitely a 'purple' cat," said owner Anna Norris. "She's very shy but loving. Always ready to snuggle, but quick to run away when guests arrive. Even so, after a couple of years of harness and leash training, she really enjoys lounging on the

front porch and poking around the plants in our backyard. We know she would not do well on a hike with so many unknowns, but in the comfort of our zone, she really thrives."

Determine Your Cat's "Purrsonality"

To assess your cat's disposition, analyze his behavior. Does he spend hours staring outside, pawing at the window and watching birds and insects? Does he dart toward the door every time it opens or exhibit other signs of boredom (see page 13)? If so, your cat may really enjoy engaging with the natural world.

However, you may already have realized that venturing into the vast unknown isn't for your kitty, and that's OK. Instead of strapping on a harness, let your kitty enjoy a little "cat TV" from the window seat. You may even want to purchase or build a catio, which is exactly what it sounds like: a patio designed especially for cats (see page 192).

Once you know where your kitty stands, it's time to take the next step—and no, that next step isn't wrestling your cat into a harness and tackling the Appalachian Trail. It's finding the right harness and doing some leash training, which will provide more insight into your cat's disposition. The safest way for your cat to explore the outdoors is on a leash, but even if you've got a seemingly fearless "green" kitty, that doesn't necessarily mean your cat is going to take to a harness. A true adventure cat is a feline equipped with the right temperament *and* the proper training.

"It's absolutely true that this is not for every cat," said Dr. Kat Miller, director of ASPCA anti-cruelty behavior research. "A feline must be easy to handle to get the harness on and off, confident enough to explore the outdoors without fear, and not so 'squirrely' as to try to wriggle out of a harness and make a break for it. I suggest trying a cat outdoors in a kitty playpen or wire dog crate first before attempting leash walking. This will give you a safe and secure way

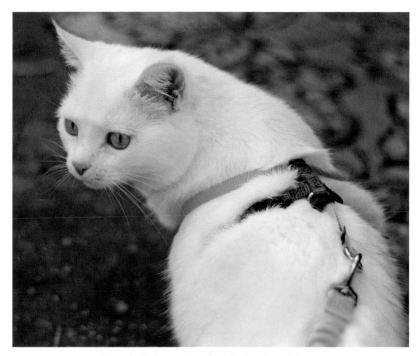

Snowflake is an adventure-loving "purple" cat.

to determine if your feline seems to enjoy the great outdoors or is frightened by it. If he seems to think this is the best thing since peanut butter and jelly, then you might try next to harness him indoors only."

After practicing some indoor harness walking, you can then introduce your cat to a quiet space outdoors to see how he does. But keep in mind that when you take your cat outside, you're introducing him to a variety of new scents, sights, and sounds that could be overwhelming, so monitor his behavior to see how he's responding to the new stimuli. If your cat seems frightened, he may be more comfortable remaining inside where the environment is more predictable. Also, if the mere sight of another feline agitates your cat, it's best to keep him indoors. Cats are territorial, and the

outdoors is home to a variety of unfamiliar scents. Your cat could become even more upset if he encounters another cat's scent—much less the cat itself.

"Many cats are actually quite timid and not at all into going outside," said veterinarian Dr. Eloise Bright. "They tend to do the same things each day. They like routine, and they like predictability. That being said, some outdoor time can be great for cats that are socialized when young—ideally before nine weeks of age—and have a more outgoing, inquisitive nature."

Older kitties that have been inside all their lives may require more training, and many may never adapt to walking on a leash. I only started leash training my two indoor cats when one was four years old and the other was three. They're both "green" kitties that adapt well to new situations; however, they're not interested in venturing past the familiarity of the backyard and that's fine with me. Just like when we're indoors, my cats are the ones making the calls.

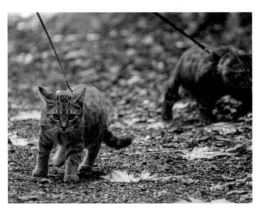

Kittens typically adapt more easily to outdoor adventures than older cats.

"You can't force a cat to be an adventure cat," said Erin Shuee, an early intervention service coordinator in Fort Collins, Colorado, who hikes with her husband and two cats in the Rocky Mountains. "It's definitely not something you want to throw your skittish adult cat into. If you want a furry, purring adventure buddy, my advice would be to start when they are young and open to exploration being a part of their lives."

Is Your Cat Bored? Know the Signs

Inactivity. It's normal for cats to nap an average of fifteen hours a day, but if your cat's only physical activity involves moving between the bed and the food bowl, your kitty likely needs some exercise and mental stimulation.

Overgrooming. All cats groom themselves, but over-grooming includes repetitive behaviors like constant licking, pulling at fur, and biting at skin, which can cause hair loss and irritation.

Destructive behavior. Every curious kitty gets into things now and then, but if you're consistently coming home to scratched furniture, shredded curtains, and broken lamps, then your cat has clearly taken to finding his own forms of entertainment.

Eliminating outside the litter box. Urinating or defecating outside the confines of the kitty toilet can be symptomatic of a variety of things, including arthritis or kidney problems, but it can also indicate a bored cat that's looking for attention.

Note: If your cat is exhibiting any of these behaviors, it may be time to see a veterinarian—what might seem like boredom may also indicate a medical issue.

The Purrsonality Quiz

1 **How much time does your cat spend gazing out the window?**

 a. All day with wide eyes and a twitching tail.

 b. On and off throughout the day with mild interest.

 c. My cat is too busy napping to notice the outside world.

2 **How does your cat respond to new situations (unfamiliar people, sudden sounds, etc.)?**

 a. Strides confidently toward them to investigate.

 b. Backs away, but remains close by to observe.

 c. Runs and hides.

3 **How often does your cat try to slip out the door?**

 a. Every time it opens.

 b. Occasionally.

 c. Never.

4 **How comfortable is your cat being handled? How easy would it be to get your cat into a harness?**

 a. My cat doesn't mind being picked up and held and would easily don a harness.

 b. My cat would take some time to warm up to a harness.

 c. My cat and I have more of a hands-off type of relationship.

5 **Does your cat exhibit signs of boredom like those listed in the box on page 13?**

 a. Yes, definitely.

 b. I'm not sure.

 c. Nope, my cat gets plenty of mental stimulation.

Results

Mostly a

It sounds like you've got an aspiring adventure cat on your hands.

Mostly b

Your kitty just may have an adventurer inside all that fur, but take things slowly to make sure she's comfortable as you venture outdoors.

Mostly c

Adventuring isn't for every cat, and you may have a kitty that's perfectly content indoors or perhaps simply better off inside due to age, health issues, or other matters. However, your cat may still enjoy lounging in a catio (see page 192).

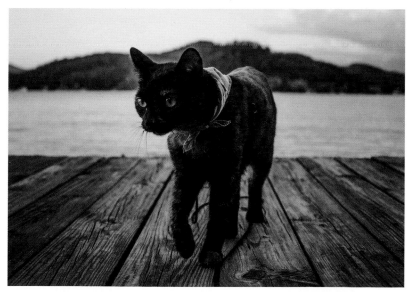

Is your cat ready to join the ranks of fearless felines like Eevee?

MEET EEVEE, WHO TURNED HER RESCUER INTO A CAT PERSON

*W*hen Georgia resident Emily Grant first laid eyes on her cat, Eevee, she admits she was "a bit of a self-professed cat hater." But after discovering the five-week-old tortoiseshell kitten and her three tiny siblings at a friend's automotive shop, Grant knew she simply couldn't leave them there. "I brought them home, and right away Eevee—who, at the time, was simply Kitten Number Three—stood out among them. She was outgoing and adventurous from the get-go. It was never the plan to keep any of them, but there was something about Eevee that stole my heart," she says.

> **"There was something about Eevee that stole my heart."**

By the time Eevee was three months old, Grant was attached to the adorable kitten, so she decided that if Eevee would take to a harness and leash, she'd keep her. "Basically, I wanted to train her to be a dog. I've always been a dog person, but when I moved in with my husband, I had to leave my dog with my mom. It's a void that I've been desperate to fill since," she says.

To Grant's surprise, Eevee was perfectly comfortable walking on a leash, so they started running errands together and taking short hikes and trips to a local lake. "As soon as I knew she was mine, we started

Eevee adapted to a leash and harness easily.

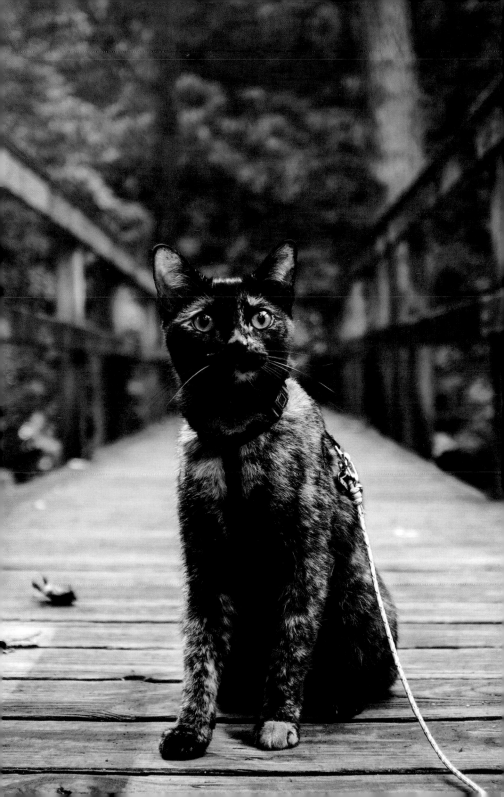

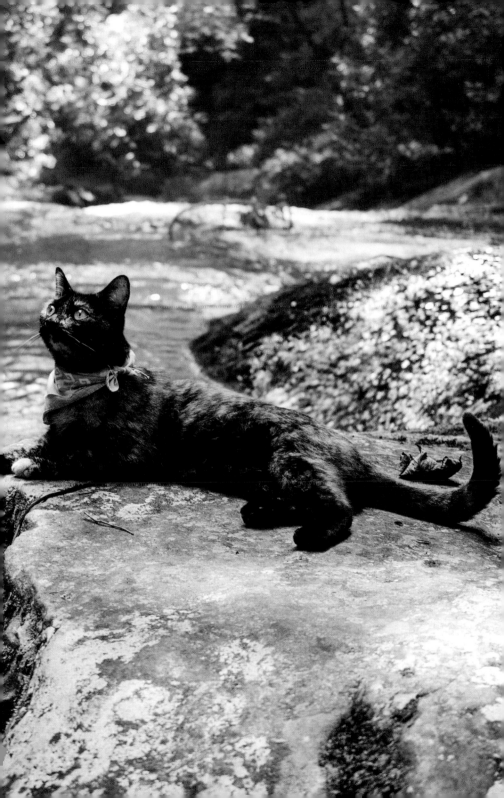

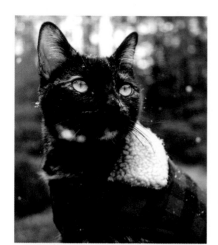

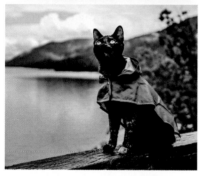

Grant makes sure Eevee is always prepared with the purrfect clothes for cold or rainy weather.

going outside all the time, and my little cat-dog impressed me over and over. My favorite memory has to be the first time I ever took her on a proper hike. I was fully prepared that day for a struggle and to carry her most of the way, but to my surprise she had her tail up and was walking ahead of me like she'd walked that trail a hundred times before."

Soon, Grant and her kitty were hiking frequently and even camping together, and they encountered plenty of people who, like Grant, didn't realize that cats could make pawsome outdoor companions. "One of my favorite things about adventuring with a cat is the reactions from people. There are a lot of adventure cats these days, and I'm so glad it's catching on, but it's definitely not the norm yet. So most people on the trail have never seen a hiking cat before, and I love talking to those people."

When they're out on the trail, Eevee tends to lead the way, but if there are off-leash dogs in the area, she stays safely inside her Outward Hound pack and takes in the view from there. And even though Eevee has some "doglike characteristics," Grant says she's definitely all cat, because Eevee is the one calling the shots. "Probably the biggest disadvantage of traveling with a cat is that—and this may be my personal experience— Eevee definitely gets moody. I usually plan our outings around her

naps. It's a bit like hiking with a toddler at times. When she's tired, she gets cranky and doesn't want to walk anymore."

But even when Eevee is being a bit ornery, Grant says she still can't imagine a more "purrfect" adventure companion. She says she's glad that this special tortie changed her mind about cats, and she hopes that Eevee will inspire others to give

> "It's amazing how a cat can enter your life and change everything for the better."

felines a chance as well. "Eevee's taught me to live in the moment, to slow down and really look at things, and I'm actually more active now because of her. I've had a pretty long history of bad experiences with cats, so our bond is particularly special. It's amazing how a cat can enter your life and change everything for the better. Eevee has consumed my life a little bit, and I've never been happier."

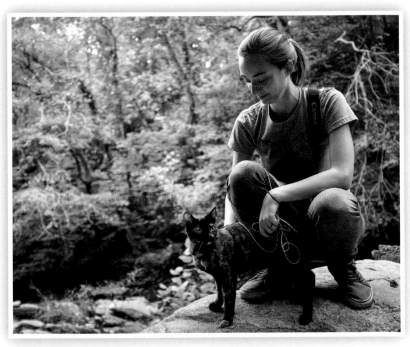

MEET VLADIMIR, THE CAT VISITING ALL 59 U.S. NATIONAL PARKS

*n*ot many people can say they've visited every U.S. national park, and no feline can yet make that claim. But soon enough, a black-and-white kitten named Vladimir will have that accomplishment—as well as several thousand miles—under his collar, and he'll make adventure cats history.

As of December 2016, Vladimir has been traveling with his owners, newlyweds Cees and Madison Hofman, in their 1989 Toyota motor home, as they make their way to all 59 U.S. national parks. They began planning this epic trip in 2015 when the Hofmans spotted a motor home on the road.

"We really wanted to get one and take a graduation trip," Madison said. "We thought, maybe we could visit a bunch of the national parks. And then, when we found out that we would graduate during the parks' 100-year anniversary, we thought, *Why not try to get to all of them*?

The Utah couple was still in college when the idea began to take shape, but they immediately got to work making their dream a reality. When they found an affordable motorhome for sale, they drove to Idaho to purchase it, and they devoted all of their spare time to prepping their new home for a cross-country journey.

"It was one leap of faith after another," said Madison. "We were newlyweds, and the RV was like our baby. In a few months, we

managed to pull off the makeover, thanks to our friends and family, a lot of all-nighters, YouTube tutorials galore, and way too much Little Caesars Pizza."

Madison didn't want to hit the road without a furry companion, so she began laying the groundwork to change her husband's mind about cats. "When Cees married me—a crazy cat lady—he didn't know it yet, but he, too, would come to love cats," she said. Madison had been wanting to adopt a cat for a long time, but Cees—who hadn't grown up with cats and knew little of their snuggly feline magic—wasn't quite onboard with the idea. But one evening, as the couple was shopping, Cees decided to make a deal.

"He somewhat jokingly said, 'Fine. You can get a cat, but today is the only day, so hopefully you can find one tonight,'" Madison said. "It was already 9 p.m., so he thought he was safe, since the animal shelters would all be closed.

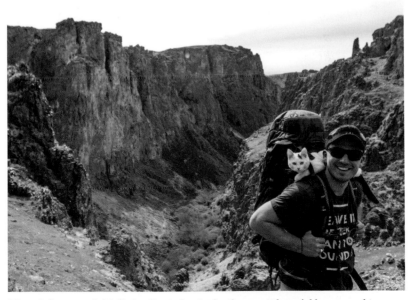

Though Cees was initially hesitant about adopting a cat, he quickly warmed to Vladimir—and now they are inseparable adventure buddies.

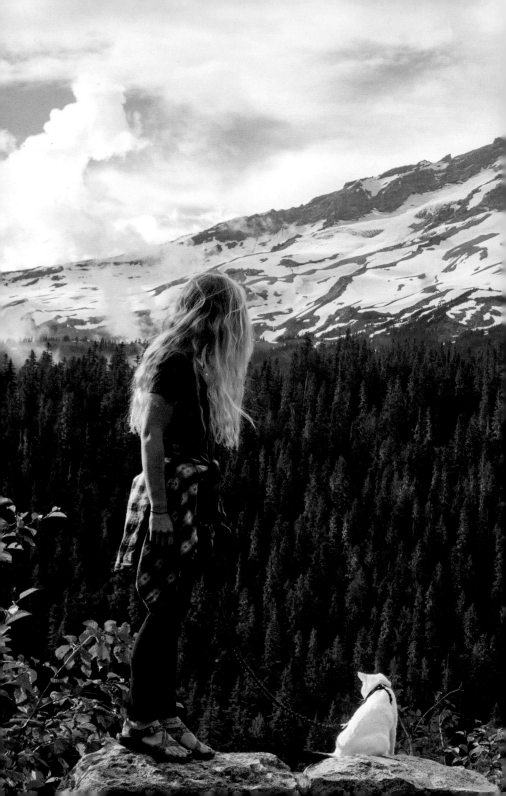

"Little did he know, I had already talked to a woman earlier that day whose kittens needed caring homes ASAP. Conveniently, we were in Target, and so I started loading up the cart with kitty supplies."

That night, the newlyweds picked up the new addition to their family: a tiny white kitten with a

Cees and Vladimir know the importance of R & R during an expedition.

black tail and a black spot on his head. It was love at first sight. "It didn't take us long to decide on a name for him," Madison said. "Cees and I both lived in Russia for a few years and speak Russian and are obsessed with everything Russian, so we named him Vladimir Kitten. We also call him Gorby for short [after the] Russian leader named Gorbachev who has the exact same birthmark on his head as our kitty."

Cees and Madison began leash training Vladimir, and once he was comfortable in a harness, they introduced him to the outdoors. His adventures began in the backyard, and later he began exploring the local parks. Before long, his parents thought he was ready to embark on their national park journey.

Cees, Madison, and Vladimir have visited nearly thirty national parks, including seven in Alaska. And while pets aren't allowed in many areas, they've still managed to let Vladimir see the sights. "If a trail or area says no pets, it's for a good reason," Madison said. "Pets are almost always allowed in parking lots, campgrounds, and paved areas. It's so fun when we find pet-friendly trails in the parks though. A lot of times you can bring your pets in kayaks on the lakes, so that's a fun option too. You really just have to research ahead of time and see what kind of adventures you can expect to have with your pet."

The Hofmans spend about three days in each national park; however, they rarely sleep inside the parks. Instead, they set up camp nearby in national forests or on Bureau of Land Management land, which is free to camp in and allows pets. "Vladimir gets most of his adventure time in the evenings after we leave the park and head to the kitty-friendly places. Sometimes we go on awesome trails just outside the park boundaries, so it has the same feel of the national park," Madison said.

As for life on the road, while it may occasionally have its disadvantages, Madison says she and Cees are both grateful for the opportunity to tour the parks and see the country's beauty. "It's so fun to wake up every day in a new place and know that the day holds endless opportunities for us," she said. "Every time we watch the sun go down on another beautiful day, I am filled with so much peace and an overwhelming sense of gratitude for the Earth and all that it gives us. We are truly so blessed with everything that is around us."

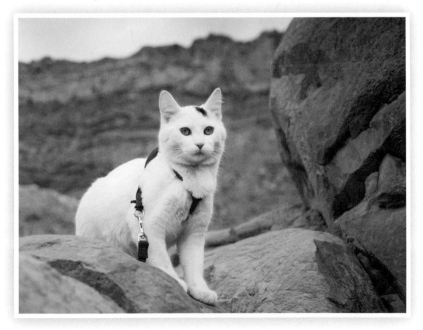

LEARN THE BASICS

>»»»›‹«««‹

SELECTING A HARNESS

The most important gear you'll need to begin training your adventure cat is a harness and leash. As a general rule, you want to select a harness that's lightweight, adjustable, and easy to put on your cat—but not easy for your cat to slip out of. Take a look online or at your local pet-supply store and you may be overwhelmed by the variety of cat harnesses available and wonder how to

The ideal harness fits snugly but doesn't restrict movement.

find the "purrfect" one for your pet. To help make the decision a little easier, we'll look at the two types of harnesses that are widely available: traditional harnesses and walking jackets or vests.

A traditional harness is composed of a few straps, often in a figure-eight configuration, which fit around a cat's neck and shoulders and fasten between the legs and around the waist. Walking jackets or vests, on the other hand, are more like tiny coats that fit snugly around a cat's body. Generally, walking jackets provide more coverage and pressure distribution, which makes them a good choice for cats that pull during walks or for those who are known (or suspected) escape artists.

"The strap type is the lightest in weight and is the one most of the cats here at Best Friends learn to walk with," said veterinarian Dr. Frank McMillan. "And because they are relatively inexpensive, they are popular to try first. The disadvantage is that they can be wriggled out of if not fitted correctly, especially if the cat gets scared and starts whirling and spinning. The vest or wrap types are more secure but are a little heavier and more expensive. Many cats

are comforted by the hugging sensation of these types of harnesses, which helps them relax."

For both types of harnesses, the leash generally attaches to a clip on the cat's back. While it's a good idea for your cat to wear a collar with tags, you should *never* attach a leash directly to your cat's collar. Cats have soft, flexible throats, so attaching a leash to the collar can easily cause choking. Also, most cats are furry little Houdinis who can easily slip out of a collar.

You may want to try a few types of harnesses to see which works best for your cat. If you have multiple cats, you may find that different designs work better for each cat because of the cat's size or personal preference. For example, my younger cat will easily let me slip a mesh harness over his head and snap it together, but my older cat doesn't like having to put his head through anything. He prefers a walking jacket that Velcros around his middle. Meanwhile, the younger cat hates the sound of Velcro and wants nothing to do with that type of harness.

 The ASPCA recommends the Come With Me Kitty harness and bungee leash, which is widely available in various colors and sizes. Many of the cats at the Best Friends Animal Society sanctuary also use these harnesses in addition to Coastal Pet's Size Right harnesses. There are also a variety of walking jackets available. One brand that cat behaviorist and *My Cat From Hell* host Jackson Galaxy recommended to *The New York Times* is the Kitty Holster, which attaches with Velcro. For cats that are sensitive to the sound of Velcro, there are also numerous other types of jackets that buckle, snap, or zip together.

However, not every adventure cat owner necessarily purchases a harness designed for the outdoorsy feline. Many have actually turned to the dog aisle because they're familiar with certain brands or simply because there are more dog harnesses available at their local pet-supply stores. "We actually use dog harnesses," said Alyse Avery, who

takes her Russian Blue, Shade, on hiking, climbing, and kayaking trips. "Grreat Choice has been an easy pick—inexpensive and the sizes we have purchased fit Shade just right."

Another popular option for cat owners is the Puppia harness designed for small dogs. Yuki, a domestic shorthair that hikes and swims alongside her owners, wears a Puppia harness when she explores the Swedish countryside, and her owner, Nathalia Valderrama Méndez, says it's the only harness she's ever used. "We think it's perfect for her being such an active kitty as it doesn't restrict any movement. It's also nice because it's a soft mesh material that doesn't suffocate or overheat her when it's hot. We did thorough research on harnesses for cats before purchasing, and we're really happy with it. We'd definitely recommend this harness."

For Yuki, the Puppia harness is the purrfect choice.

Regardless of which harness style or brand you choose, fit is the most important factor. You want to be sure that the harness is snug enough to prevent escape but not so tight that it restricts movement or makes your cat uncomfortable. If you're trying to determine which size harness is right for your cat, refer to the harness manufacturer's guidelines if available.

Also, it's important to make sure your harness is in good shape each time you put it on your cat. Before each outing, inspect it for rips and tears, clean fur out of any Velcro attachments, and make sure that any snaps or push-locks attach firmly.

HOW TO LEASH TRAIN A CAT

While most cats can be trained to walk on a leash, it's important to keep in mind that leash walking isn't for every cat and that some may take longer to adapt to this new experience than others. The best time to introduce your cat to a harness is as a kitten because she'll be naturally more accepting of it; however, older cats can also learn to walk on a leash if you're patient and provide plenty of rewards.

1. INTRODUCE THE HARNESS.

The key to getting your cat used to a harness is making it a positive experience—and that means food. You can begin by leaving the harness by your cat's food dish or by simply holding out the harness so he can sniff it and then feeding him treats afterward.

It's also a good idea to help your cat get accustomed to the sounds of the harness. Practice snapping it together or undoing the Velcro to get your kitty used to these new sounds so they won't be startling when he's actually wearing the harness.

2. TRY IT ON.

Now that your cat is aware of the harness, slip it on him, but don't fasten it yet. Provide more treats as a distraction and to help your cat associate the harness with a positive experience.

"Put the harness on right before mealtime, so that the dinner distracts him from the new sensation and keeps him from focusing on removing it," said veterinarian Dr. Kat Miller. "Do this several days in a row until he seems comfortable with it."

3. LEAVE IT ON.

Once your cat is comfortable at this step, you can fasten the harness and practice adjusting the fit. You should be able to fit one or two

Let your cat get accustomed to the harness indoors before venturing outside.

fingers between the harness and your cat's body—but no more than that. Keep in mind that cats may try to back out of the harness when they're frightened, so be sure it fits snugly and doesn't need to be exchanged for another size or a different fit.

Leave the harness on your cat for a few minutes, and then provide another food reward before taking it off. Repeat for several days, paying attention to how your kitty reacts to the harness. If he seems comfortable in it, leave it on a bit longer, but if he gets frustrated or upset, provide a food distraction and slip the harness off. Try again later with a better treat—perhaps some yummy canned food or tuna—and remove the harness sooner this time before your cat reacts negatively. It's important to always end your training sessions on a positive note.

Remember that it's normal for cats to freeze up, refuse to walk, or walk very strangely the first few times they're wearing a harness. Your cat has likely never experienced the sensation of something on his back before, so it's going to take some time to adjust to it.

4. ATTACH THE LEASH.

It may take several days or even weeks to get your cat comfortable in the harness, but once your kitty is used to putting it on and walking normally, it's time to attach the leash. Opt for a basic leash, as

retractable ones could injure your cat. "They can easily snap
and will cause a nasty rope burn if your cat gets entangled," said
Dr. Bright.

Take your cat into a room where he's not likely to get the leash
tangled on furniture or anything else, and then attach it to the
harness. You may want to let the leash drag behind him as you feed
him treats and engage him with toys. However, a dragging leash
can be alarming for some kitties, so if this is the case, simply hold
the leash and keep it slack as your cat wanders freely.

When your cat is comfortable with the feel of the leash, practice
following him around inside your home, keeping the leash loose
in your hand. Continue to provide plenty of treats and praise
throughout this process.

5. GUIDE YOUR CAT.

Once you've both had some practice with this, it's time to try gently
guiding your kitty. Apply a little pressure on the leash and call your
cat to you. When he comes, reward him with a treat. If you've done
clicker training before, you can also use a clicker to reinforce the
notion that he's performed a desired behavior.

"You want to make sure he does not freak out when he feels
pressure on the leash holding him back and that he doesn't wriggle
his way out, leaving you holding a leash and empty harness as he
dashes off. Again, do this several days in a row," Dr. Miller said.

6. GO OUTSIDE.

If your cat has mostly interacted with the outdoors through the
window, it's likely he's going to be on high alert when you bring him
outside, so take things slowly and proceed with caution.

"Go slow," said Craig Armstrong, who hikes, camps, and climbs
with his cat, Millie. "In the beginning, I'd take Millie to a tiny island in
a pond at a local park. I only had to guard the bridge for her escape.

This way she could explore outside safely but not get scared and bolt off and never be found."

But you don't have to take your kitty far to help her get used to nature. You can start in your backyard—and if it's fenced in, that's even better. When you think he's ready to venture outdoors, pick up your harnessed kitty and *carry* him outside to a quiet area free of people and other animals. Place him on the ground and stay beside him as he gets acquainted with this new environment. Let him decide when he's ready to do a little exploring. It's your job to simply hold on to the leash and keep it loose as you follow behind your cat. Don't force your cat to venture farther than he's ready to go.

"Until it's clear that the cat is comfortable outside it's a good idea to be prepared for a possible 'freaking out' episode if the cat becomes severely frightened," said Dr. McMillan. "Carry a heavy towel that can be used to quickly wrap up the panicked cat without becoming scratched or bitten and bring the cat inside. The first few trips outside should be near the door that leads back inside, with the door open. In becoming accustomed to the outside, the cat should know that he or she can seek safety back inside anytime things become overwhelming. After a few trips this will no longer be necessary."

Keep in mind that walking a cat is different from walking a dog. While your cat may happily accompany you on long walks, he may prefer to simply sniff around your yard and doze in the sun. Other cats may hike for a little while and then nestle atop your backpack and

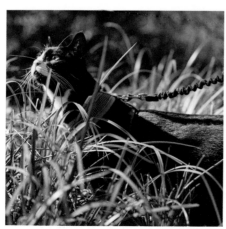

Let your cat set the pace on your first outdoor expedition.

let you do all the work. Regardless, it's important to pay attention to what your cat is comfortable doing; don't force him outside his comfort zone. Just like at home, your kitty makes the rules.

Leash-Walking Tips from the Purrfessionals

Heed the advice below to ensure that every walk is enjoyable for both you and your feline friend.

Don't let your leashed cat walk out the door on his own. Carry him outside every time.

"I always recommend that pet parents carry their cat outdoors, rather than letting the cat walk outdoors on his own," Dr. Miller said. "The reason is to reduce the tendency for door-dashing when the leash is not on: A cat who is used to walking out of his own accord when the leash is on probably will try to do that at other times as well."

Don't put the harness on your cat when he's pestering you for a walk.

"Don't take your cat out when he is crying to go outside. Otherwise you'll be rewarding the crying behavior and you will be hearing a lot more of that in the future," Dr. Miller said.

Practice patience.

"It's hard not to compare cats to dogs when you start leash training," said Georgia resident Emily Grant, who hikes with her cat, Eevee. "Some cats may take to it easily, while others may take months to get comfortable. That being said, it's totally worth it. Cats are adventure companions like no other."

« «« ‹ «« «« «« ‹ «« «« ‹ «« «« ‹ «« «« «« ‹ «« «« «« ‹ «« «« «« ‹ «« «« ‹ «« «« ‹ « ««

CLICKER TRAINING

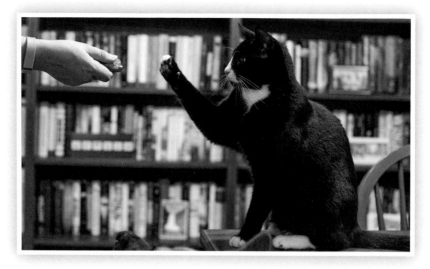

You may have attempted to train a cat before. Perhaps you used the same stern "no" you used to scold your puppy, or maybe you squirted your kitty with a water pistol when she scratched the corner of the couch. It's likely your cat didn't even acknowledge the "no" that made your dog tuck his tail between his legs, and your cat probably still scratches the furniture (only now she knows not to do it in front of you).

Cats don't respond to negative reinforcement because they don't associate your punishment with their own actions—they associate it with you. So when you shout at your cat or squirt her with water, you're teaching her to fear *you*. Though they don't respond to punishment, cats can be trained through operant conditioning, a concept that teaches that behaviors have consequences. One of the most effective methods, clicker training, uses positive reinforcement to implement desired conduct. If you've leash trained your cat using the guidelines in How to Leash Train a Cat (page 33), then you already know the basics of providing rewards for desired behavior.

Why Clicker Train a Cat?

If you're going to be heading outside with your feline friend—
even just into the backyard—it's best to be prepared for anything.
What if a sudden noise or your neighbor's dog spooks your kitty
and she bolts? What if she slips out of her harness or darts into your
neighbor's yard? You'll feel more at ease if you can trust your cat to
respond to commands you've practiced.

Clicker training also has numerous other benefits. "The top
benefit of clicker training is mental stimulation," said veterinarian
Dr. McMillan. "Cats are highly intelligent creatures and, as such,
require a regular source of stimulation to keep the brain functioning
optimally. Clicker training provides enjoyable mental stimulation,
which is not only fun in and of itself, but by elevating the cat's
happiness can also often resolve many of the unwanted behaviors
stemming from an unfulfilled existence. Finally, clicker training
creates a strong bond between the cat and the cat's owner. The two
become true partners."

What You'll Need

- A clicker (a small device with a metal
 strip that makes a clicking sound) or a
 clicker app. For deaf cats, you can use
 a penlight or flashlight instead.
- Some treats or food your kitty enjoys
- A target stick (a stick with a small ball
 on one end)

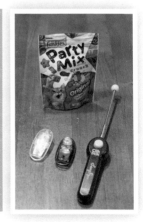

1. "CHARGE" THE CLICKER.

The first step in clicker training is to help your cat establish a connection between the sound of the clicker and a tasty treat. Making the clicker a desirable reward is called "charging the clicker"—you're imbuing it with value, so your cat wants to perform certain behaviors to hear that satisfying click. When you have your kitty's attention, click the clicker and immediately reward her with a small treat or a bite of yummy canned food.

Some cats may immediately make the connection between the clicking sound and the treat, but you may need to repeat this process several times for your kitty. After all, cats learn from repetition just like we do. Once your cat makes the association, you've successfully charged the clicker and it's time to start working on some behaviors.

2. INTRODUCE THE TARGET STICK.

A target stick is a useful training aid because it shows your cat where to focus her attention. To begin, place the target stick close to your cat's nose, and when she sniffs it, immediately click and reward the behavior. You can also put a bit of wet food at the end of the target stick to help get your cat's attention. Next, move the target beside your kitty, so she'll have to turn in order to sniff it. Again, click and reward. Continue this process, moving the stick farther away each time, until your cat is following it.

3. TEACH YOUR CAT TO SIT.

Dogs aren't the only ones who can follow voice commands. Once you've charged the clicker and practiced with the target stick, you can teach your cat to sit. Start by holding the target above your cat's head and say "sit." With her nose pointed toward the target, your cat should naturally move into a sitting position. As soon as her rump nears the floor or surface you're working on, click to indicate the desired behavior and provide a food reward.

Even kitties who prefer indoor adventures may enjoy clicker training.

Purrfect Your Clicks

- Keep training sessions to no more than a few minutes at a time.

- Click at the right moment to indicate the desired behavior.

- When you begin teaching your cat something new, start small and reward him for steps he makes along the way. For example, if you want to teach your cat to enter his carrier before you head out for a hike, begin by clicking and rewarding him for moving toward the carrier, then for standing next to it, and finally for entering it.

- Don't click more than once to indicate a desired behavior. Multiple clicks can be confusing.

- Don't try to push your cat into the desired position or move him where you want him to go. Your cat's movements should always be voluntary.

- Never punish your cat for not performing the desired task (it may backfire!).

HERE'S KITTY! TEACH YOUR CAT TO COME WHEN CALLED

Coming when called is an important skill for an adventure cat to master. If your kitty slips out of a harness or pulls the leash right out of your hand when darting after an insect, you'll be grateful that you've practiced this simple command. It will also come in handy at home if you ever need to find your cat.

Luckily, you've probably already trained your cat to come when called. If your cat runs to you when she hears the sound of a crinkling treat bag or a lid popping off her canned food, she's already responding to an auditory cue. You simply need to build on what's already a strong association for your cat.

1. PICK A NAME.

Decide how you plan to call your cat. If she has a lengthy name like Millicent of the Meowntains, you'll need to shorten it so she'll easily recognize it. You likely have many adorable nicknames for your kitty, but don't expect her to respond to all of them. Pick one and stick with it to help her make the association. And if you'll often be adventuring with a friend, spouse, or anyone else, be sure they always call the cat in the same way to avoid confusing your pet.

2. MAKE AN ASSOCIATION.

Help your cat make the association between your call and a treat. Stand right next to your cat when you call her. Immediately follow this with the crinkling of the treat bag, and then provide a treat.

3. TAKE A STEP BACK.

When your cat recognizes that your call results in a tasty reward, it's time to start working on coming when called from a greater distance. Start by moving a few feet away from your cat. Say the animal's name

and then crinkle the bag. As soon as your cat comes, reward her with a treat. If you've been clicker training your cat, you can also use a click to reinforce the desired behavior.

4. GET SOME MORE DISTANCE.

When your cat is coming consistently, gradually increase the distance your pet must cover in order to be rewarded.

5. KEEP PRACTICING.

Once your kitty has mastered this, you can practice calling her from different rooms and during times when she's distracted. If your cat is already leash trained, take her outside and practice calling her and rewarding her when she's busy sniffing the air and investigating the grass. It's important to practice this skill in an environment that closely mimics the one where you'll be adventuring because the outside world is full of distractions.

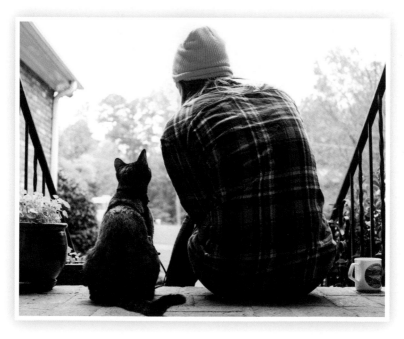

‹‹

Pawsitivity Is Key

If you want your cat to come every time you call, here are a couple of things to keep in mind.

Always reward your cat.

Even if you've been calling her for several minutes and she finally, reluctantly, wanders down from the bookshelf, give her a treat. Responding to your call isn't a natural behavior for your cat so it must be rewarded every time.

Don't call your cat's name in anger or punish her when she comes.

And don't call her so you can give her medicine or whisk her away to the vet. In these situations, it's better to go find your cat. If she starts to associate hearing her name with something negative, she may not come in a situation when it's imperative that she does.

Can You Teach a Deaf Cat to Come on Command?

Deafness can be caused by a variety of factors, and some cats—including many all-white, blue-eyed cats—are born deaf. But just because your kitty can't hear you doesn't mean he can't learn to come to you. It simply means that instead of using a verbal cue, you'll have to use a visual one.

A portable light source like a penlight or flashlight is a good tool to use as a visual cue. You can also wave your hand or stomp your foot on the floor to cause vibrations your cat can feel. Pick the cue that works best and be sure to reward your kitty with a treat every time she comes.

HOW TO READ FELINE BODY LANGUAGE

Cats may seem like mysterious creatures that are impossible to read, but our feline friends are actually communicating with us all the time. We just have to know what to look for. Through their body language and facial cues—the position of their ears, shape of their tail, and size of their pupils—cats can tell us if they're comfortable, afraid, aggressive, or even ready to play.

Being able to accurately gauge your cat's mood is especially important when taking him outside. If you can tell that your cat is truly enjoying himself, you may want to extend your hike and venture into new terrain, but if your cat seems frightened or on edge, you'll know it's time to head back indoors. "Cats give off very subtle fear signals to start with," says Dr. Bright. "Most will crouch down and make themselves small when they are worried. They will also freeze and move just their ears to localize threats. Cats that are comfortable will be openly exploring the environment."

The following illustrations will help you better understand felines' nonverbal cues. However, it's important to take other factors into consideration when assessing a situation, including the environment, your cat's personality, and your cat's comfort level with being harnessed and outdoors.

Tail

Tail up

Both a straight-up tail with flat fur and a tail held high with a curve at the tip like a question mark indicate a happy, playful, approachable cat.

Tail down

A cat that's carrying his tail low to the ground may be indicating that he feels threatened and may act aggressively. However, some cat breeds tend to carry their tails low, so it's important to know what's typical behavior for your pet.

Tail tucked between legs

This tail position means a cat is anxious or fearful. There's likely something in the environment that your pet is responding to negatively.

Tail straight up with fur on end

If your cat's tail suddenly becomes big and bushy, you've got a severely agitated animal on your hands. Cats puff up like this in an attempt to look larger and frighten off the perceived threat.

Tail moving slowly back and forth

This slow-swishing tail often means a cat is curious, and the animal's attention may be focused on something in particular, such as an insect. You may see this tail movement occur just before your cat pounces.

Thrashing tail

When a feline's tail is whipping back and forth rapidly or slapping the ground, this indicates an irritated cat that may act aggressively.

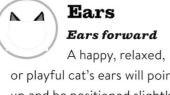

Ears

Ears forward

A happy, relaxed, or playful cat's ears will point up and be positioned slightly forward.

Ears straight up

When a cat's ears stand at attention like this, the animal is alert because something has caught her eye.

Ears sideways and partially flattened

This kitty is irritated, anxious, or frightened.

Ears turned back or flat

When a cat's ears go back like this, it's a sure sign that the animal is fearful or angry and may act aggressively.

Eyes

Alert and blinking

This kitty is actively taking in the world around her.

Constricted pupils

This may indicate that a cat is agitated; however, keep in mind that cats' pupils will also constrict in brighter light.

Dilated pupils

A cat's pupils will dilate when he becomes fearful or angry.

Slow blinking

This action indicates that a cat feels safe and comfortable. In fact, the slow blink is said to be a cat's way of smiling at you.

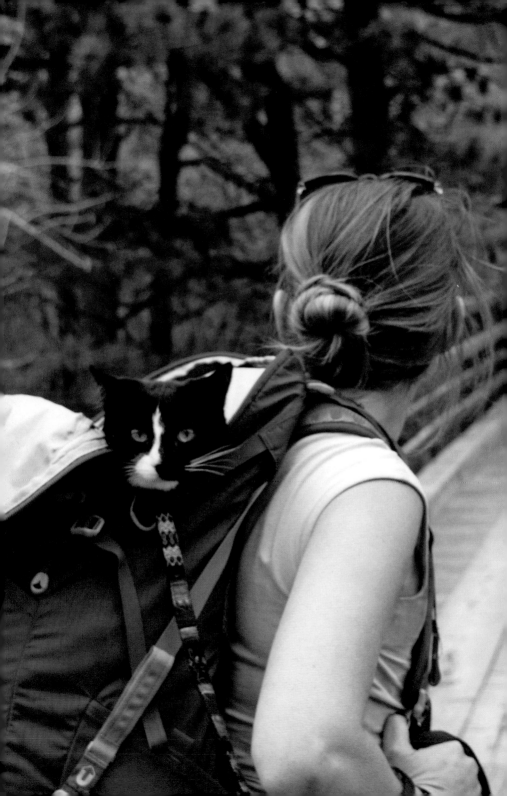

HAPPY TRAILS: HOW TO TRAVEL WITH CATS

Some of the best kitty adventures may take place in your neighborhood or even your own backyard, but if you don't have a yard or quiet space to take your cat to—or if your kitty has more adventurous ambitions—you'll have to travel. Often this will entail a short drive in the car, but even a quick road trip can be a stressful experience for cats that aren't accustomed to going for a ride. Before embarking on a long trip with your cat, consider other options. While you may want to bring your kitty along for your vacation, he may be much happier staying home with an experienced pet-sitter and greeting you upon your return. But if you must travel, take steps to ensure the trip is as enjoyable as possible for your feline friend.

Select a Carrier

The safest way for your cat to travel—whether it's by plane, train, or automobile—is in a carrier. Yes, even if you're just taking a short trip in the car. While you may like for your kitty to curl up in your lap or have the opportunity to look out the window and enjoy the scenery, a free-roaming cat is dangerous for both of you. An adorable cat can be a distraction, of course, but, worse, if your cat becomes frightened or overstimulated, he may dart about the car or attempt to hide at your feet near the pedals. You also run the risk of injuring him in the event of a sudden stop or an accident. Plus, an unrestrained kitty may dart out an open door or window, so play it safe and keep your cat in a carrier.

A carrier keeps kitty safe and comfortable while traveling.

You'll want to choose a carrier that's easy to clean, well ventilated, and specifically designed for cats. You'll also want to look for a carrier that can be easily secured in a vehicle, such as those that feature a slot for a seat belt. The carrier should be large enough for your cat to stand up, stretch, and easily turn around in, but not so large that he'll slide around or feel uncomfortable. While you may think they will enjoy extra space, cats actually feel more secure in a carrier that's just large enough for them to stand in without crouching.

Many carriers may come with padding, but if yours doesn't, line it with a blanket or towel. It's a good idea to use one that smells of home to help your kitty feel more comfortable when you're on the go.

Get Your Cat Accustomed to Carrier Travel

Most cats have limited experience with car rides, which can involve unfamiliar sights, sounds, scents, and motions. And often the only time they venture into their carriers is for a trip to the veterinarian, which is hardly an enjoyable destination. So if you want your cat to not only be comfortable in the carrier but also to not run away and hide when you bring the carrier out, you'll have to help her associate the carrier with positive experiences. (Sound familiar?) The best time to do this is when cats are young and very open to new experiences. However, if your cat is fully entrenched in middle age, don't despair— even older cats can get accustomed to carrier travel with time and patience.

Teaching your cat that the carrier is a safe place to enter willingly is one way to reduce travel anxiety. Start by feeding your cat treats or even meals near the carrier. As she gets more comfortable, gradually move the treats or food bowl until she's eating entirely inside the carrier. Make the carrier an inviting space by lining it with a blanket, towel, or bedding, and consider spraying it with a cat-hormone spray like Feliway that helps ease stress and anxiety.

Leave the carrier door open and add treats and toys that will encourage your cat to enter and investigate. You can also use a target stick and clicker to help your cat get accustomed to the carrier (see page 39). Simply have your cat follow the stick near and eventually into the carrier, and use the clicker and a food reward to indicate the desired action.

Once your cat is comfortable with the carrier, practice closing the door for a few minutes at a time while your cat is inside. You can even provide a distraction such as a favorite toy, catnip, or a long-lasting treat for your cat to enjoy while she's in the carrier. As your cat becomes more relaxed inside, close the door for longer periods of time and occasionally feed her treats to ensure the experience is positive.

Now that your cat is accustomed to spending time in the carrier, help her get used to the sensation of being picked up and moved while riding inside. Start small by picking the carrier up and placing it back down after a few seconds, and slowly work your way up to trips around the house and then a trip outside to the car. Be sure to provide food rewards frequently.

Be sure to reward your cat so she will continue to make a positive association with riding in the carrier.

Once you make it to the car, practice placing your cat in the car—preferably in the backseat away from potentially dangerous airbags—buckling the carrier in, and shutting the car door. Eventually, work your way up to turning the car on while your cat is inside, and once she's comfortable, begin taking trips around the block.

On the Road

Place your cat's carrier in the backseat, preferably in an area that's out of direct sunlight, and be sure to secure the carrier with the seat belt. If you have several hours' worth of driving ahead, plan to make a pit stop every couple of hours so your cat can drink water, stretch his legs, and have access to the litter box.

When you stop, be sure it's in a safe, quiet location, and don't open the car door until your cat is securely attached to the leash. Never leave your cat alone in a parked car. A quick stop to use the restroom may be no big deal for you, but just a few minutes alone in the car is too much for your cat. Even if the windows are rolled down, on a warm day, the interior of a vehicle can quickly reach life-threatening temperatures.

Even a quick pit stop can be a good excuse for your cat to get out and stretch his legs.

Road Trip Essentials

Food and water
Bring the food your cat is accustomed to eating, as well as the water your cat is accustomed to drinking. Feeding your cat the usual diet will decrease the chance of an upset stomach.

Litter box and litter
There are plenty of foldable, reusable boxes on the market, as well as disposable trays. Be sure to pack some of your cat's usual litter, as well as a scooper and disposable bags.

Records
Pack your cat's vaccination records if you'll be crossing state lines, as some states require rabies records for all pets.

Medicine
If your cat is on any medications, or if your vet suggests motion-sickness meds, be sure to bring them along.

Recent photo of your cat
Keep a recent picture of your cat on hand to show people or to print on flyers in case the unthinkable happens and your cat gets lost.

Toys
Toss in a favorite toy or two to make your cat more comfortable on the road.

Before Your Road Trip

- Make sure your cat is microchipped and wearing a collar with ID tags.
- If you're embarking on a long trip, search for pet-friendly hotels and emergency vet locations along your route prior to departing.
- Play with your cat before you leave to help him work off some energy.
- Feed your cat a few hours before getting in the car unless your veterinarian suggests otherwise.

Air Travel

Before booking a flight for you and your kitty, weigh your other options. Is it possible to drive to the destination? Could you leave your cat home with a pet-sitter or even at a boarding facility? Air travel can be extremely stressful and even potentially dangerous for cats, especially for felines with short nasal passages, such as Persians.

When flying with cats, it's best to book a direct flight.

If you must fly with your cat, talk to your veterinarian first and have your pet examined to ensure that he's in good enough health to fly. Call the airline well in advance of your travel date to book your flight, because planes allow only a certain number of pets on board each flight. Also, some airlines require that health documentation be submitted for your pet months before a flight. Be sure to confirm that your pet will be flying in the cabin with you. While animals that fly in a plane's cargo hold usually will be fine, some have been lost, injured, or even killed during commercial flights, so avoid putting your cat in cargo. Also, inquire about immunization requirements and if the airline requires a specific type of carrier. If you'll be flying to another country, thoroughly research health, immunization, and quarantine requirements.

Flying with Felines: Tips for a Smooth Ride

- Your cat's carrier should have a tag that provides your name, cell phone number, and destination information.

- Arrive at the airport early to allow plenty of time to get through the security line. Keep in mind that your carrier will have to go through the security scanner as well. You'll have to remove your cat from the carrier and carry or walk him during the screening, so be sure he is on a leash. You may want to request a secondary screening that won't require you to remove him from the carrier.

- Don't give your cat any tranquilizers or medications unless your veterinarian has prescribed them.

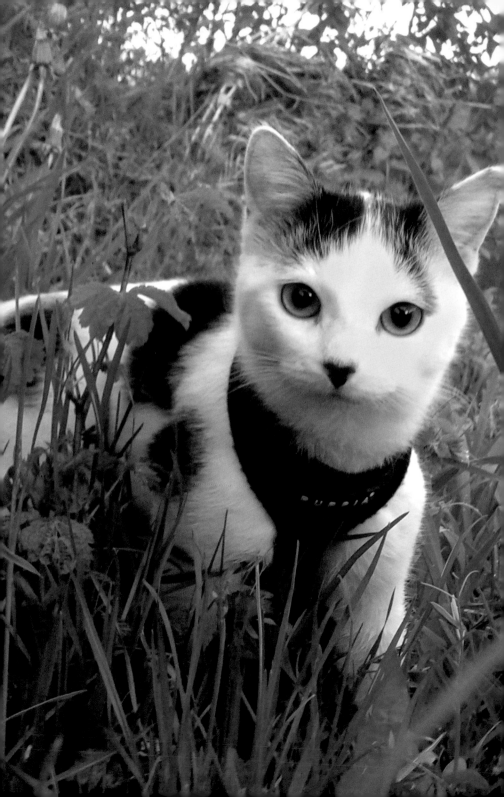

Talk to Your Vet

Just as you should consult your veterinarian before taking your cat outside, it's a good idea to consult your vet before embarking on a long road trip or taking your cat on a flight. Some airlines actually require a certificate of veterinary inspection, and you'll always want to make sure your cat is in good health and up to date on vaccinations and any medications. If you're planning a particularly lengthy trip or will be flying with your cat, you may also want to ask your vet what to do if your cat experiences motion sickness.

Does Your Cat Have Motion Sickness? Be Aware of the Signs.

The best way to prevent motion sickness is to acclimate your cat to traveling, but sometimes cats will still get sick. Familiarize yourself with these symptoms and talk to your vet before embarking on a trip to see if he or she recommends keeping any medications on hand.

- Drooling
- Vocalization
- Immobility
- Vomiting
- Urinating or defecating

MEET BOLT AND KEEL, CANADIAN RESCUE KITTIES

*K*ayleen VanderRee was hiking in a British Columbia park in July 2015 when she and her friend Danielle Gumbley stumbled upon a couple of kittens in a bush behind a garbage bin. "The kittens looked clearly abandoned and to be about four weeks old, with no owner or mother cat in sight. We couldn't bear to leave them to be picked off by an eagle or cougar so we decided to take them home with us," VanderRee says.

They planned to take the tiny kittens to a local shelter; however, when they arrived, the office was closed. The young women had scheduled a two-night canoeing, hiking, and camping trip for the next day, and with no one to watch the kittens in their absence, they decided to bring them along.

"Since we found them in a bush, we figured hiking up a mountain wouldn't be too far out of their element," VanderRee says. "By the end of the trip, they had survived two days of rain and made their way into our hearts. The thought of giving them away was no longer an option."

They named them Bolt and Keel, and the courageous kitties now accompany VanderRee and her friends on countless outdoor expeditions. While Bolt and Keel mostly tag along on hiking trips,

There's no shortage of adventure opportunities in Victoria, British Columbia—with its mild climate, access to mountains and ocean, and abundance of hiking trails.

VanderRee says they've also "been on a short canoe trip, spent a week on a sailboat, gone kayaking on the ocean, camped on the beach, and crossed a river to hang out at the bottom of a rock-climbing wall."

However, VanderRee's favorite memory with the kitties was when they awoke at sunrise to hike the base of Vancouver Island's Triple Peak—

"Since we found them in a bush, we figured hiking up a mountain wouldn't be too far out of their element."

with not only Bolt and Keel in tow, but also a folding kayak. "On the way up, we had to figure out how to cross a river and got to see Bolt and Keel experience snow for the first time. They blew past all our expectations as they often climbed the scrambling parts better than we did. When we reached the lake at the top, they curled up for a nap and looked so content. After a quick kayak and snack break, we started to venture back to the car. It was an intense, challenging, and full day, but it really showed us what was possible."

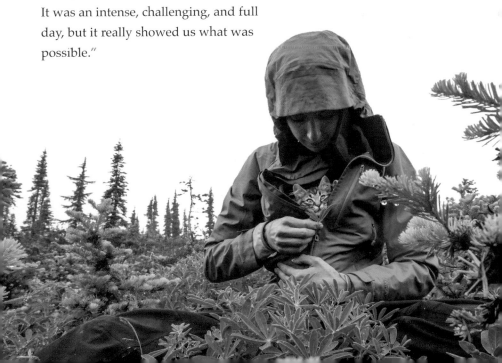

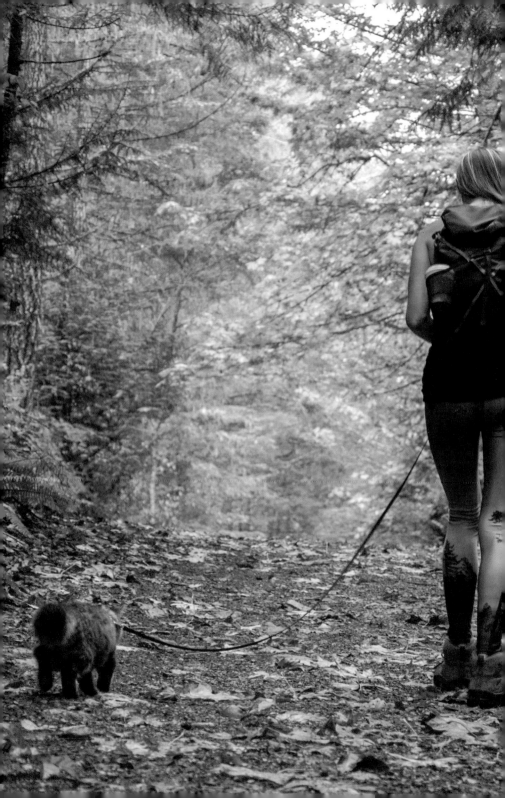

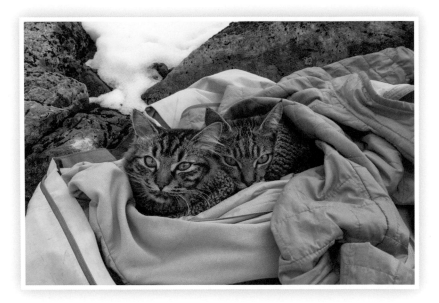

"The adventures that are most successful are ones where we let the cats move at their own speed."

However, despite the opportunity for nonstop action and exploration, VanderRee says that moving at a slower pace is also enjoyable. "The adventures that are most successful are ones where we let the cats move at their own speed and take the time to be curious with them."

Both VanderRee and Gumbley view each trip with Bolt and Keel as a training opportunity, and they're always focused on letting the cats decide when they're ready to take the next step. "Each time they get outside, walk on leash, or hang out in a kayak, they get more comfortable and bold," VanderRee says. "Bolt has always been curious about water and one day decided to walk on the deck of a kayak. He ended up going for a quick swim before being pulled out. This incident barely seemed to faze him,

and each time he encounters water he becomes more comfortable with it." Watching Bolt and Keel engage with nature and continually venture outside their comfort zone has been a source of inspiration for VanderRee, who says the kittens have changed the way she views the world. "These cats have helped me through a lot and helped me to relate to nature in a fun, new way. They have brought so much joy and laughter into my life and into my friendships. They have taught me to stay curious and to not be afraid to test my own limits."

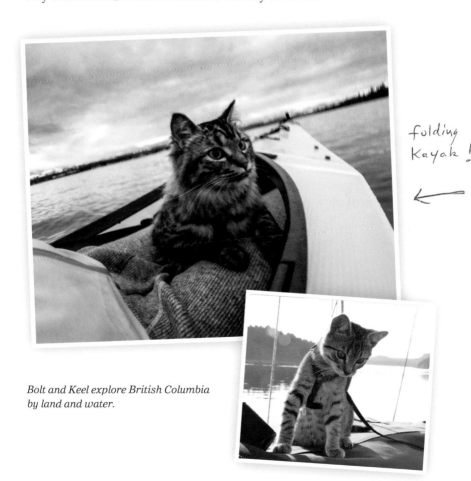

folding Kayak!

Bolt and Keel explore British Columbia by land and water.

MEET FLOYD, "THE LION"

One glance at Floyd the Lion and you might assume his name comes from his magnificent silky mane; however, there's much more to being a lion than simply looking the part. It requires strength, courage, and a certain fearlessness when it comes to putting that whole cats-have-nine-lives rumor to the test—and Floyd certainly fits the bill.

Since he went home with Susie Floros in November 2013, this lionlike Persian has had one adventure after another—and not always the good kind. During his first year of life, Floyd underwent multiple vet visits and an MRI, and it was discovered that he was born with only one sinus cavity. Not long after, a German shepherd chased Floyd off a balcony, and the fluffy cat fell twenty feet onto the concrete below. "He wasn't even a year old and I was convinced he was gone," Floros says. "We rushed him to the emergency vet and after thorough tests and overnight observation, we found out Floyd miraculously only cracked his two front canines when he landed. Relieved, we brought the little guy home and scheduled his root canals."

Not even a week later, Floros was out of town when she got a call that Floyd had gotten into lilies, which are toxic to cats. "His system was flushed out and Floyd proved once more that he was, in fact, as strong as a lion and that cats do have nine lives," Floros says.

Luckily, Floyd seems to be staying out of trouble these days, and he gets his fill of adventure on hikes throughout sunny Colorado. Most of Floyd's excursions take place around the neighborhood with

his best friend, a Goldendoodle who helped Floyd adjust to life on a leash.

Floros says that walking with Floyd is always a "slow-paced adventure," but it's certainly a worthwhile one. "Adventures with Floyd have taught me to appreciate the little things along the way. Floyd likes to choose the obscure routes. He's taught me to slow down and watch the birds."

> **"Adventures with Floyd have taught me to appreciate the little things along the way."**

Recently, Floyd embarked on his biggest adventure yet with a trip to Moab, Utah, an outdoor paradise for mountain bikers, off-roaders, and, of course, furry four-legged explorers. During the trip, Floyd hiked alongside his owners and ventured all the way to Corona Arch. When he got tired, he took well-deserved breaks in his Outward Hound backpack. "The best part of adventuring with Floyd is letting him experience the outdoors in a safe way. He's an indoor cat, and it's fun

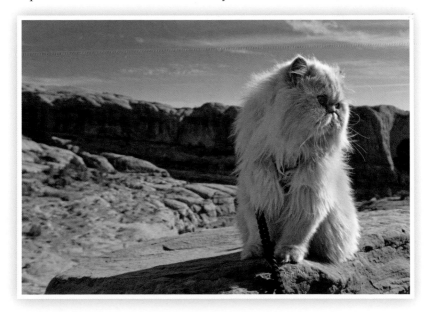

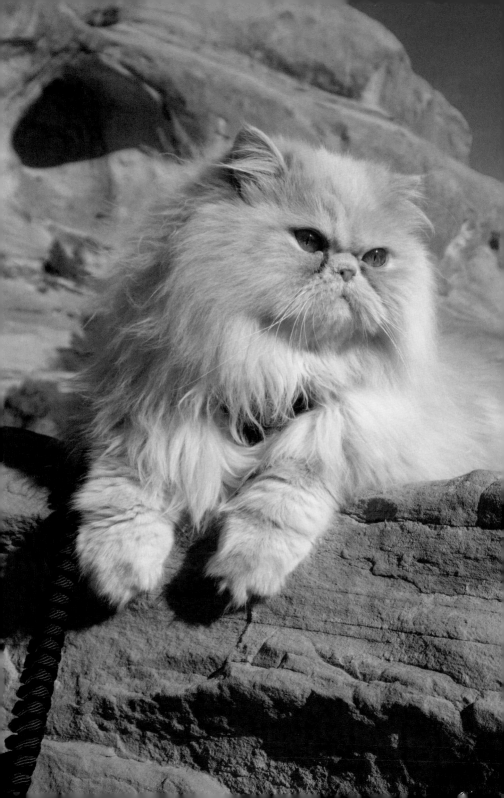

"Floyd brings so much love and happiness into our lives."

to see him so happy and curious when we go for walks," Floros says.

When they're outside—whether it's on the trail or in the neighborhood—Floros does everything she can to preserve Floyd's remaining lives, so she always puts safety first. "Floyd travels in a cat carrier for road trips, is always in a harness, is chipped, and has a collar with his ID tag," she says.

And while this little lion may look a bit fierce with that full mane, Floros says he's all cuddles. "Floyd brings so much love and happiness into our lives. I love how he crawls onto my pillow in the early morning and rests his chin on my head while he purrs. He also greets us with his tail up whenever we come home. He's a very loving cat who makes our lives full."

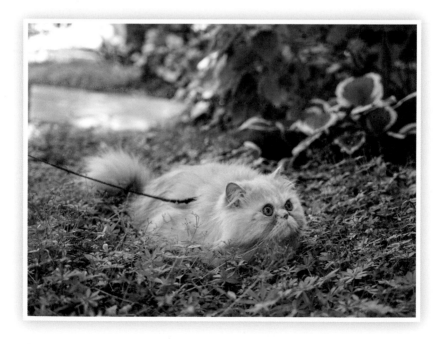

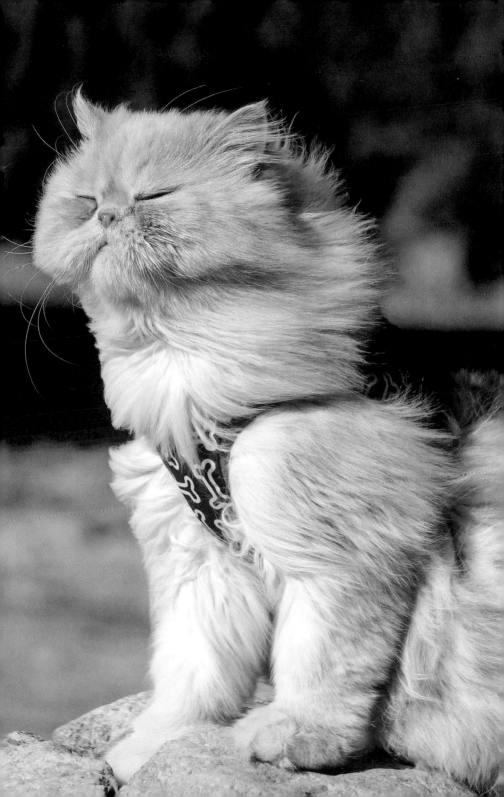

SAFETY FUR-ST

>·>»·>»·>· ·<·«·«·«·<

HOW TO BUILD A FELINE FIRST AID KIT

When you're adventuring with your kitty, it's important to always put safety first, and that means having a well-stocked first aid kit for both you and your feline friend when you set out on an adventure. You wouldn't forget to bring bandages and sunscreen if you and a human friend were going on a hike, would you?

You likely have a pretty good idea of what belongs in a first aid kit for yourself, and luckily, the kits designed for cats aren't too different. In fact, a good way to start assembling a first aid kit for felines is by purchasing one for people and adding a few select items to it. You can also buy a cat-specific kit online or from your local pet store.

If you're starting from scratch, first obtain a waterproof box or case and tape the following phone numbers and addresses inside. (It's also a good idea to program these numbers into your phone.)

- Your veterinarian
- The local 24-hour emergency vet
- ASPCA Poison Control Center (1-888-426-4435)

Putting the "Kit" in First Aid Kit

You may already have many of these supplies in your own first aid kit, but this comprehensive list includes a few cat-specific items.

- Paperwork (The Humane Society suggests including proof of rabies-vaccination status and copies of any other important medical records.)

- Absorbent gauze pads

- Antiseptic wipes, lotion, or spray

- Cotton balls or swabs

- Hydrogen peroxide

- Eyewash (The human version is OK to use.)

- Ice pack

- Nonlatex disposable gloves

- Rectal thermometer

- Petroleum jelly to lubricate the thermometer

- Sterile nonstick gauze pads for bandages. (The Humane Society recommends self-cling bandages, which stick to themselves but not to fur.)

- Scissors with blunt ends

- Tweezers or tick key

Your cat's first aid kit should also include anything your veterinarian has prescribed or recommended for your pet, especially any medications. Remember to regularly check these supplies and replace any expired items.

Other supplies to consider:

- **Cat first aid book.** Familiarize yourself with basic
 first aid, as well as the book's organization, so you can
 quickly find the information you need in the event of an
 emergency. The book *Cat First Aid* by the American Red
 Cross is a good resource. Or if you don't want to lug a
 book around, download the American Red Cross pet
 first aid app, or take a pet first aid course.

- **Towel and/or muzzle.** If your kitty is sick or injured,
 you may need these items to protect yourself while you
 administer first aid.

- **Diphenhydramine, aka Benadryl.** This can be
 useful if your cat has allergies or is stung by an insect.
 However, you should include this medication *only* if
 it's approved by your veterinarian, who can tell you the
 proper dosage to administer.

*Adding a few cat-specific items to a basic first aid kit won't take too much time—and
your kitty will be grateful.*

DO CATS NEED SUNSCREEN?

You know it's important to slather sunscreen on yourself before heading outside, but you may never have considered doing the same for your cat. However, felines—even those with long, thick fur—are susceptible to sunburn and even skin cancer. While hairless breeds and cats with fine or light-colored hair are especially vulnerable, every cat is at risk for sun damage, particularly on the ears, nose, belly, and groin.

Sunburns on cats look similar to those on humans. They appear as red, irritated patches of skin that are sensitive to the touch. In some cases, sun damage can cause hair loss. If you suspect your cat is sunburned, visit your veterinarian. If the burn has resulted in infection, your vet can provide a topical cream for treatment or antibiotics. The best way to prevent sunburn is to avoid sun exposure, but even if your cat never ventures outside, he undoubtedly enjoys napping in those afternoon sun puddles by the window. At home, one of the easiest ways to limit your kitty's exposure to UVA and UVB rays is with a UV-filtering window film. These come in clear and tinted varieties and can be found at most home-supply stores. However, if your kitty is going to be venturing outdoors with you, you may want to consider a feline-friendly sunscreen.

Many of the common ingredients found in human sunscreen are toxic to cats, including zinc oxide, ethylhexyl salicylate, homosalate, and octyl salicylate. And because felines are such meticulous groomers, you want to be sure that the sunscreen you use isn't going to harm your pet in the inevitable event that he ingests it. "If you intend to use a sunscreen on a cat, be certain that the product labeling specifically states that it is appropriate and safe for cats," writes Dr. Carol S. Foil, a board-certified specialist through the American College of Veterinary Dermatology. "Although some baby sunscreens may be safe for pets, avoid human sunscreens that have

ingestion warnings because these products contain ingredients that can be toxic if licked by a dog or cat."

Look for hypoallergenic, fragrance- and dye-free products that are formulated for use on cats, but don't be surprised if these sunscreens don't feature sunburn-prevention claims on their labels— the FDA doesn't test pet sunscreens. Also, keep in mind that some sunscreens marketed for pets may contain toxic ingredients like zinc oxide along with a bitter component to discourage animals from licking the cream, so be sure to read labels carefully and *never* use a product on your cat until you've consulted your veterinarian.

When applying sunscreen to your cat, focus on the areas that are most at risk for sunburn, including the ears, nose, belly, and groin. If your cat is hairless, you'll need to apply sunscreen more liberally, and you may also want to consider investing in clothing to protect your pet from the sun's rays. If your cat develops a rash or has any reaction to the sunscreen, wash it off immediately and contact your veterinarian.

While a feline-friendly sunscreen may offer some protection for your pet, it should always be used in conjunction with other efforts to reduce sun exposure. This means providing shade for your cat at all times and trying to stay indoors during the peak sun hours between 10 a.m. and 3 p.m. when possible. "The best way to avoid sun damage and skin cancer is to avoid the sun during the hot part of the day, particularly for white cats or cats with pink noses and ears," says veterinarian Dr. Bright. So you may want to consider taking your hikes in the early morning or late afternoon.

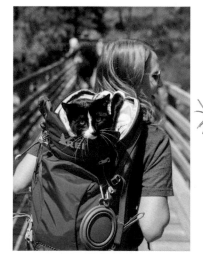

Keep in mind that just as your sunscreen can wear off, so can your cat's, so be sure to reapply it.

14 ESSENTIALS

When you head out for a hike, camping trip, or any other adventure, it's best to be prepared for everything from a serious injury to inclement weather. And when you go on an adventure with your cat in tow, you need to "purr-pare" even more. Luckily, as a human living in a cat's world, you're already accustomed to catering to your feline's every whim. So before you set off with your cat, make sure you have everything you need. The list below includes the ten essentials for every outdoor excursion, as well as a few extra items for your kitty.

Of course, the items outlined here are only the very basics—no one knows your kitty better than you, so pack anything else he may require, especially any medications.

1 Hydration

Make sure to bring plenty of potable water for both you and your cat. Pack the same water your cat is accustomed to drinking at home, along with a collapsible water bowl.

2 Nutrition

If you think you'll need to eat on the trail, keep in mind that your cat probably will, too. Pack nourishing, lightweight snacks for yourself, and bring your cat's regular food and treats along as well.

3 Navigation

Even if you swear your kitty has a great sense of direction, pack a map and compass just in case. A GPS is great to bring along, but a compass weighs less and doesn't rely on batteries.

4 First aid kit

You may be on a short nature hike, but it's still a good idea to bring along a first aid kit that's equipped to treat both you and your cat. For the complete rundown on what a feline first aid kit should contain, turn to page 72.

5 Sun protection

You'll need sunscreen and sunglasses, and your kitty may need sun protection as well, especially if he's a hairless breed or has light-colored fur. Turn to page 74 to learn more.

6 Fire

Even if you're not planning to camp out, bring matches in a waterproof case or pack waterproof ones. If you do have to start a fire, be sure

to practice caution and keep your
kitty—and his leash—away from the
flames.

7 Illumination

Unlike your adventure cat, your night
vision probably isn't so good, so pack
a flashlight, lantern, headlamp, or
other light source, as well as some
extra batteries.

8 Insulation

Weather conditions can change
quickly, especially if you're venturing
into the mountains, so dress in layers
and bring an additional layer, as well
as rain gear.

9 Pocketknife or multi-use tool

A knife, screwdriver, and scissors
can help you do everything from
opening a can of cat food to cutting
bandages. And don't forget about
the powers of duct tape—the original
low-budget, multi-use tool. Wrap
some duct tape around your water
bottle or trekking poles and use it to
do everything from patching holes to
removing splinters.

10 Emergency shelter

You may not be planning to spend
the night, but if you get lost or injured
you'll be grateful you packed a tent,
tarp, emergency blanket, or even
simply a large trash bag.

11 Collar and ID tags

Your cat should always have easily
readable identification tags with your
name, address, and phone number.
Some states actually require cats to
wear identification at all times. It's
also recommended to have your pet
microchipped before ever heading
outside.

12 Harness and leash

Your cat should wear a harness
and leash at all times when you're
outside. Add reflective tape or LED
lights to the harness and leash to
help your cat stay visible.

13 Recent photo of your cat

Carry an up-to-date photo of your
kitty or keep it on your phone. (Yes,
Fluffy was adorable as a kitten, but
if you're hiking with a five-year-old
Fluffy, that photo won't be a lot
of help.) If you and your cat get
separated, you can show your pet's
photos to other hikers, and you'll
have an image ready to photocopy or
print if you need to put up flyers or
posters nearby.

14 Poop bags and/or litter box and litter

The principles of Leave No Trace
apply to kitty waste too, so it's best
to clean it up and carry it out.

WHAT ABOUT THE LITTER BOX?

When you head out for a day hike or a night in the woods, you know to bring along a few items so you can do your "business"—namely some toilet paper and that trusty trowel. But what about your cat? Can he just go in woods? Do you need to pick up his waste? Do you have to hike with a litter box in tow?

Well, it depends. We spoke with several adventure-cat owners to get the dirt on going in the dirt. Here are their suggestions for how you can keep your kitty comfortable in the great outdoors while taking care not to harm the ecosystem.

On the Road

"We always bring a little litter box in the car that fits nicely behind the seat on the floor." —Erin Shuee

"On day trips, we do not bring a kitty litter box. Zhiro is pretty good about using the outdoors or refraining from going to the bathroom in the car. On multi-day trips we will bring a litter box, especially if there is a lot of driving." —Lacy Taylor

On the Trail

"We also have disposable litter trays about the size of your hand, and we'll bring a tiny scoop of litter in a Ziploc to offer a potty break."

—Erin Shuee

"While hiking, Josie will occasionally wiggle to let me know she needs down, will find a spot, eliminate, and is ready to march onward again." —Erin Dush

At Camp

"The desert's pretty much a giant sandbox litter box to her, so Millie takes care of that on her own." —Craig Armstrong

"We brought a litter box the first time, but he didn't use it. He always looks for a soft patch of dirt and spends a good couple minutes digging and then goes there and buries it." —Haley O'Rourke

THE CHOICE IS YOURS . . .

Option A: The World Is Your Litter Box

Your cat may have no problem learning to use the bathroom along the trail; however, you should pick up after your pet just like you would if you were hiking or camping with a dog, particularly because cat feces can contain harmful bacteria.

Option B: The Actual Litter Box Option

Think your kitty would prefer all the comforts of home? No problem. There are numerous options available for collapsible and reusable litter boxes, as well as disposable, biodegradable ones. Check your local pet-supply store or visit AdventureCats.org for suggestions.

HOW TO PREVENT DEHYDRATION IN CATS

Just as you can get dehydrated when out on the trail, so can your adventure cat. Even if your kitty is simply lounging around the yard soaking up some sun, it's easy for her to become overheated and lose fluids. However, dehydration is more than simply water loss—it's also a loss of electrolytes like chloride, potassium, and sodium, which are necessary for biological processes. Because your cat can't tell you when she's feeling poorly, it's important to be able to recognize the signs of dehydration.

Is Your Cat Dehydrated?

Here are the symptoms to look for:

- **Panting**
- **Dry gums and mouth**
- **Lethargy**
- **Loss of appetite**
- **Elevated heart rate**
- **Decreased skin elasticity**

One way to test for dehydration is to check the elasticity of a cat's skin through "tenting." Simply pinch the skin over a cat's shoulders and gently pull it up. When released, the skin should snap back into place. However, if the animal is not properly hydrated, the skin may stay up or return to normal very slowly. If you notice this condition, don't take it lightly: The cat is severely dehydrated and should be taken to a veterinarian immediately.

Causes of Dehydration

While overheating and increased physical activity can both cause dehydration in cats, there are other causes as well—anything from inadequate water intake to occasional vomiting or diarrhea. Also, dehydration is often symptomatic of other health problems, so it's important to consult a veterinarian if you suspect your pet is dehydrated.

It's especially important to stay hydrated when exploring arid terrain.

Cats most susceptible to dehydration are senior cats, nursing cats, and cats with cancer, diabetes, hyperthyroidism, or kidney disorders.

How Much Water Does a Cat Need?

The amount of water your cat requires to stay healthy depends on a variety of factors, including the cat's size, the time of year, and the food your cat consumes. The type of food your cat eats can affect how much water she needs on a daily basis because dry food contains much less water than wet food. While it's imperative that all cats have access to clean drinking water regardless of their diet, it's especially important to monitor cats on a dry-food diet to ensure they're consuming enough H_2O. If you're not sure whether your cat is drinking enough water, talk to your veterinarian.

Hydration on Adventures

Before you head out for a hike or campout with your kitty, check the weather and the trail terrain. If it's a particularly long or challenging hike, or if the temperatures are high, it might be best for your cat to sit this adventure out. Also, travel can be very stressful for cats. Motion sickness during car rides can cause nausea and vomiting,

which can lead to dehydration, and the stress and low humidity during air travel may have the same effect. Therefore, it's important to provide access to clean water if you're taking a trip.

Before embarking on that hike, make sure you've packed enough water for you and your cat. It's a good idea to bring the water your cat is accustomed to drinking—she may turn her nose up at water that smells or tastes different. Also, pack something for her to drink from, such as a collapsible water bowl.

"Cats don't tend to drink water on walks like dogs do, but it's still a good idea to carry a small bottle of water and a small dish to offer some water every twenty to thirty minutes," says Dr. McMillan.

Sometimes it can be difficult to get cats to drink, so a great way to encourage them to increase their liquid intake is to offer them something smelly and delicious that they can't refuse. A can of wet food may tempt your kitty, or try hydration treats like Churu Purées.

Preventing Overheating

Don't take your cat out on hot days.

If you're heading out for a midday summer hike, it's best to let your kitty sit this one out, especially if your cat is very old or young, is overweight, has a heart or respiratory condition, or is a short-nosed breed such as Persian and Himalayan. "Cats differ in their tolerance of heat based on such things as body size and coat," says Dr. McMillan. "The best rule is again to imagine the cat as a human infant or use the commonsense rule that if it's uncomfortable for you, it likely is for the cat."

Water from lakes or streams may contain harmful parasites or bacteria— remember to bring your own H_2O.

Watch the humidity.

It's not only the temperature that matters but also the humidity, so if you live in a humid area, you should limit your cat's time outside during warm months. "Animals pant to evaporate moisture from their lungs, which takes heat away from their body," veterinarian Dr. Barry Kellogg told the Humane Society. "If the humidity is too high, they are unable to cool themselves, and their temperature will skyrocket to dangerous levels very quickly."

When it's hot outside, your kitty can still explore. Just keep your walks short and close to home.

Keep your walks short.

If you go outside on a warm day, keep the trek short, rest often, and limit your cat's activity. During the summer, you may want to keep your adventures close to home—such as in your own backyard—so you can get back inside and cool off quickly.

Don't shave your cat.

The same fur that insulates cats in winter helps them avoid taking in too much heat in summer, which is why you shouldn't shave your cat unless your vet recommends it.

Be prepared.

Bring along plenty of water, as well as an umbrella or another way to provide shade if you'll be hiking in an area without tree cover. You may also want to consider other supplies, such as a cooling pad. "I'm a big fan of the Chilly Pad," says Erin Shuee. "It's a cloth that you can get wet before your hike, wring out, and it stays super cool for the

remainder of the day. We'll put Quandary in the pack with it, and she stays as cool as a cucumber."

Never leave your cat alone in a vehicle.

On warm days, the temperature inside a vehicle can rise quickly to life-threatening levels. Even if you leave the windows cracked, in only a few minutes the temperature can get high enough to cause irreversible organ damage or even death.

Watch for signs of overheating.

Signs of heatstroke include panting, salivation, rapid heartbeat, breathing difficulties, lethargy, excessive thirst, vomiting, seizures, and unconsciousness. If you suspect your cat is suffering from heatstroke, seek veterinary help immediately.

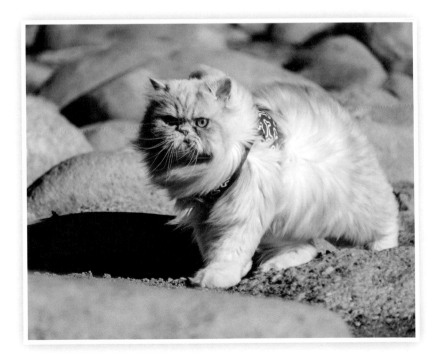

AVOIDING TOXIC PLANTS

Even though cats are carnivores, it's not uncommon for them to chew on plants. Often this is bad news for the plant but won't harm your kitty at all. However, there are plenty of plants on the trail, in your backyard, or even in your home that are toxic to cats, and ingesting them can cause reactions ranging from nausea and vomiting to seizures and even death.

What to Do If You Suspect Poisoning

If you catch your kitty gnawing on a plant that you can't identify, call your veterinarian or the ASPCA's Animal Poison Control Center. Watch your cat for symptoms of poisoning, and keep careful track of any symptoms and how long they've been present to help your vet with a diagnosis. If you suspect your cat has ingested toxic plant matter, take a photo or specimen of the plant with you to the vet to aid in identification. If your cat has vomited or regurgitated the plant,

Signs of Poisoning in Cats

Symptoms will vary based on what your cat has ingested, but here are some common signs to watch for:

- Vomiting
- Diarrhea
- Abdominal pain
- Redness, itchiness, or swelling of the skin or mouth
 - Excessive salivation
 - Difficulty breathing
 - Excessive drinking and urination

you can bring along a sample of this as well so your vet can test the plant matter or check for evidence of an infection.

Your veterinarian may suggest that you induce vomiting or administer medication at home; however, don't attempt either unless your vet advises you to do so.

Prevention Is the Best Policy

Before bringing a plant into your home, be sure that it won't harm your cat in the event she decides to take a nibble. If there's any question, it's best to err on the side of caution. Keep in mind that cats are natural explorers and excellent climbers, so never assume that a plant is out of a curious kitty's reach. And if your cat has developed a taste for plants, provide a pot of grass or catnip for him to eat when the craving strikes—one that you know is free of fertilizers, pesticides, and other chemicals.

When you're outside, your cat should always be on a leash, which will enable you to keep her from munching on the local vegetation. However, accidents do happen, so it's important to know what to do should your cat ingest a toxic or potentially toxic plant. Don't assume that your own yard is safe. Some of the greatest adventures take place close to home, so keep your garden and flower beds free of toxic plants (to learn how to design a feline-friendly garden, see page 195).

Finally, be prepared in case of an emergency. Have your veterinarian's number and the ASPCA Animal Poison Control Center hotline programmed into your phone. You may also want to download the APCC app, which contains information on a variety of toxic substances, including plants.

The 24-hour ASPCA Animal Poison Control Center is open 365 days a year and can be reached at 1-888-426-4435.

Common Plants to Avoid

These plants commonly found in the wild (or in your garden!) are toxic to cats and should be avoided at all costs. For a complete list of toxic and nontoxic plants, visit aspca.org/ pet-care/animal-poison-control/toxic-and-non-toxic-plants.

- Aloe
- Amaryllis
- Autumn crocus
- Azalea
- Begonia
- Caladium
- Carnation
- Castor bean
- Cyclamen
- Daffodil
- Dumb cane
- English ivy
- Foxglove
- Holly
- Larkspur
- Lily

- Milkweed
- Mistletoe
- Morning glory
- Oleander
- Poinsettia
- Rhododendron
- Sago palm
- Sweet pea
- Tomato
- Tulip
- Wisteria
- Yew

Is It Safe for Cats to Eat Grass?

Cats often vomit after chowing down on grass, which leads many owners to suspect their pets are sick or that grass isn't good for them. But cats sometimes eat grass for essential nutrients like folic acid, and they later regurgitate the plant matter they can't digest. However, while eating grass is a perfectly normal feline behavior, if you notice yours is eating more grass than usual or vomiting frequently, consult your veterinarian.

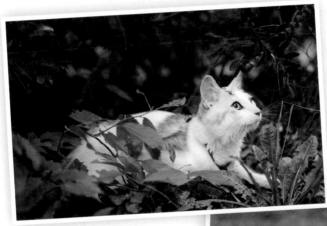

If your cat likes a green treat now and then, set out a small tray of cat grass in your home for her to snack on.

KITTY MEETS WILDLIFE: WHAT TO DO IF YOU ENCOUNTER OTHER ANIMALS

Besides the pets in your household and the occasional unlucky moth, your cat has likely never encountered other animals. But when you venture outside, your cat may come face-to-face with the neighbor's dog, stinging insects, and many other creatures, so it's important to know how to keep your kitty safe—and keep the local wildlife safe from your kitty.

When you take your cat outside, remember that you're also taking a predator into nature, so don't be surprised if your cat wants to stalk or pounce on prey. Even kitties with full bellies may react instinctively when they spot a bird, lizard, or chipmunk. Studies have found that outdoor cats may kill billions of birds and small mammals a year, which is another reason why it's vital that you keep your cat on a leash. You may also want to consider attaching a bell to your cat's collar. "Having a bell on your cat's collar is really helpful—for you, because then it's easier to know where they are, but also for other animals, especially any birds they may be trying to hunt," said Nicole Gaunt, an Alaska resident who adventures with her cat.

Your kitty's natural curiosity may lead her to think that insects are toys to play with.

Other Pets

If you're going to be hiking on pet-friendly trails, it's likely that you'll encounter dogs and possibly even other adventure cats. While some cats may be comfortable meeting other animals, most will prefer to avoid such encounters. Keep an eye and ear out for other hikers, and if you spot a dog coming your way—especially an off-leash one—scoop up your cat. Cats feel safe when they're off the ground and can observe what's going on down below, so if your cat is comfortable riding on your shoulder or atop your backpack, place her there and keep on walking.

Spiders and Insects

Before you ever let your cat place a paw outside, make sure he's up to date on flea, tick, and heartworm medication. Even if your cat gets treated regularly, it's a good idea to check him for bites or unwanted visitors that may have burrowed into his fur.

Felines are naturally curious, so your cat may want to investigate the buzzing, flying, and crawling critters she encounters, but deter her from getting too close—you don't want her to get stung, bitten, or poisoned. If your kitty does wind up with a sting from a bee, wasp, hornet, or yellow jacket, it's likely that there will be only some localized pain or swelling. However, just as some people have more severe reactions to stings, so do some cats. If your cat vomits, has diarrhea, experiences trouble breathing, or shows any other unusual symptoms after a sting, get to a vet immediately.

Likewise, if your cat is bitten by a spider, seek veterinary assistance—a bite from a venomous spider like a black widow can be deadly. Keep your cat away from areas where these spiders make their homes, such as stumps, logs, and piles of brush.

Snakes

The best way to prevent snakebites is to avoid encountering snakes in the first place. Around the yard, take simple precautions like clearing away excess brush and cleaning up food or birdseed that can attract rodents—and therefore snakes. When out on a walk, avoid long grass and shrubbery, and while your feline is surely curious, don't let him dig under rocks or explore beneath logs.

Snakes will typically try to avoid you and bite only as a last resort, but cats may instinctively approach them or even pursue them. If you see a snake, steer clear of it and turn back the way you came. Don't even let your cat investigate dead snakes—biting is a reflex that a snake's body can have even hours after death. Remember that snakes don't have to coil before they strike, and they can strike across a distance equal to nearly half their body length.

It's a good idea to familiarize yourself with the types of snakes in your area, especially venomous ones. If a bite occurs, being able to identify the snake could save your cat's life.

If your cat is bitten, try to remain calm. Remove his collar and harness and try to limit his activity. If possible, keep the bitten body part below heart level so that venom doesn't travel farther into the body through the bloodstream. Seek veterinary care immediately. Don't waste time trying to kill the snake, and don't attempt to suck out the venom, bleed the wound, or apply ice or a tourniquet.

Birds of Prey

Raptors—such as hawks, eagles, and owls—hunt and feed on small animals, so it's important to stay close to your cat and practice extra caution if your pet is outside around dusk or at night. "Smaller hawks are not going to attack small dogs or cats, but larger ones and eagles will," said Dr. Stokes. "But if a person is very close to their cat, such attacks are very unlikely."

Larger Wildlife

Before you head out, familiarize yourself with the wildlife that lives in your area and learn what to do if you encounter a bear, coyote, mountain lion, or other animal, and prepare yourself accordingly. If you live in a particularly wild or dangerous area, or if attacks have been reported recently, leave your cat safely at home.

When you hit the trail, keep these tips in mind:

- Keep your cat on a leash. You don't want him to wander off and attract a predator's attention—or come running back to you with a predator in pursuit.

- Be prepared to pick your cat up in the event you encounter unexpected wildlife.

- Stay on the trail, and keep a close eye on your surroundings, especially in areas where you have limited sight lines.

- Watch for animal tracks, fresh scat, and other signs that wildlife may be active nearby.

- If you're hiking in bear country, carry bear spray with you and know how to use it. Making noise as you hike or attaching bells to your pack or to your kitty's collar is also a good idea, so wildlife will hear that you're in the area and can avoid you.

WHAT TO DO IF YOUR CAT GETS AWAY

E ven with a snug-fitting harness and a leash-trained kitty, accidents can occur, so it's important to know how to handle the unthinkable. If your cat suddenly darts out the front door or wriggles out of her harness on a hike, here's what to do.

Stay Calm

You may be panicking, but don't scream, yell, or chase after your cat. This will only further frighten him. Instead, gently call your cat's name and, if you can see him, approach cautiously and scoop him up.

Search Nearby

If your cat is accustomed to being indoors and only ventures outside on a leash occasionally, it's very likely he's hiding nearby. Cats are territorial animals and your kitty's domain is inside, so if your cat suddenly finds himself outside in unfamiliar territory, he's going to hide. Search the area thoroughly, and don't expect your cat to respond to the sound of your voice—scared kitties don't call for help.

Bring Out the Food

Place food or treats—the smellier, the better—around the area to tempt your kitty out of hiding.

Use a Flashlight

If it's dark, shine a flashlight around the area. Cats' eyes will shine when the light hits them. Also, lost cats are often more willing to leave their hiding places at night, so don't give up the search when night falls.

Practice Prevention

Before you go outside, check your cat's harness for wear and tear and ensure it's fitted properly. Also, get in the habit of carrying your cat out the door every time the two of you go out so she doesn't develop a habit of door-dashing. Finally, keep a recent photo of your cat in your wallet or on your phone so that you'll have it ready to show other hikers or to make a lost-cat flyer. You may also want to download the ASPCA's mobile app, which will help you devise a search plan for a variety of circumstances.

If your cat is frequently outdoors, like Vladimir, he should be microchipped and always equipped with a collar and tags with your contact information.

ARE YOU PURRPARED?

Before you clip on your kitty's leash and head out the door for an adventure, make sure you can answer "yes" to all of these questions.

- Has your cat been checked out by a veterinarian, and did your vet say your cat is healthy enough to adventure?
- Is your cat up to date on vaccinations and flea, tick, and heartworm treatments?
- Does your cat have a collar with up-to-date ID tags?
- Is your cat microchipped?
- Does your cat have a snug-fitting harness, and is she comfortable wearing it?
- Do you have all the adventuring essentials packed and ready to go?
- If your adventure requires car travel, does your cat have a carrier to ride in?
- Are cats allowed in the park or outdoor area that you plan to visit?
- Will you be with your cat for the entire trip?
- Is this the type of adventure your cat will enjoy? (Word to the wise: While your kitty may like a casual paddle on the lake, she likely won't appreciate a trip down Class IV rapids.)

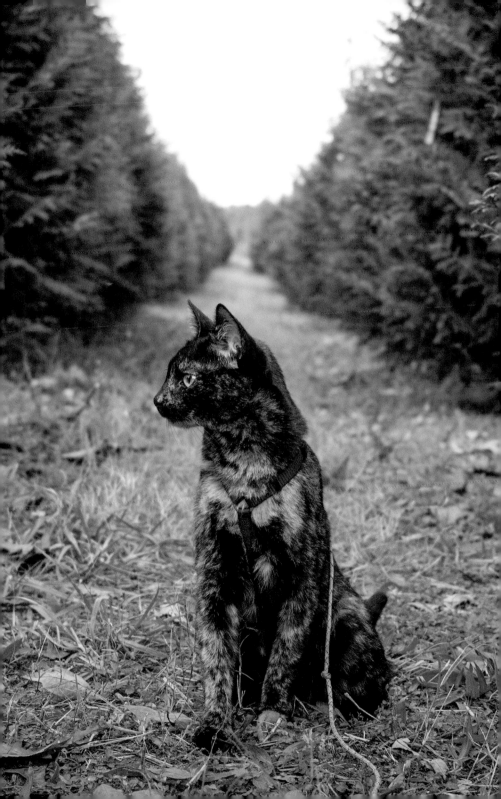

MEET SHADE AND SIMBA, BEST FRIENDS AND ADVENTURE BUDDIES

Climbers Alyse Avery and Michael Anderson had two cats in their Las Vegas home, but they'd been wanting a third one—an adventurous "crag kitty" to accompany them on climbing trips—and on November 8, 2014, their wish came true. "My partner, Michael, surprised me with Shade for my birthday," Avery says. "He went to a few shelters searching for the right cat that would become our crag kitty. He spent some time with her, played with her, and just knew she was the one. Shade was rescued from a cat hoarder and taken to a local shelter, and we brought her into our life of adventure."

Shade, a Russian Blue, was already several months old and took to the outdoors quickly. Two weeks later, she was on her first climbing trip in Red Rock, Nevada. It was a chilly day, so when she was done exploring, she crawled into Avery's jacket to enjoy the view. "I think my favorite day with Shade was the first time we took her rock climbing," Avery says. "She spent the majority of the day in my coat, snuggled up warmly against me. Ever since then, she has added some extra fun to our adventures."

"She spent the majority of the day in my coat, snuggled up warmly against me."

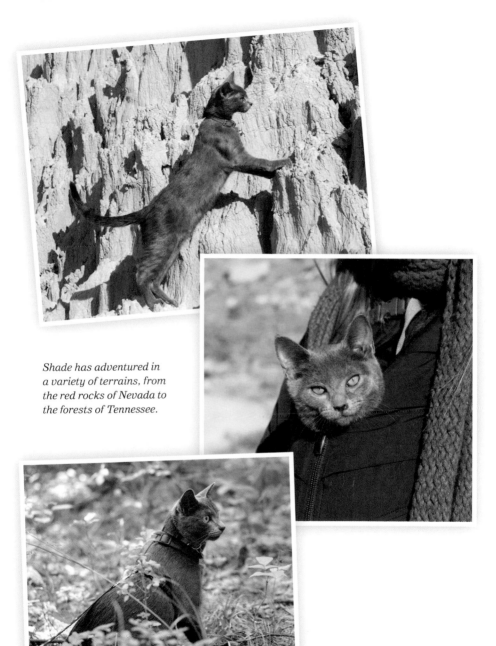

Shade has adventured in
a variety of terrains, from
the red rocks of Nevada to
the forests of Tennessee.

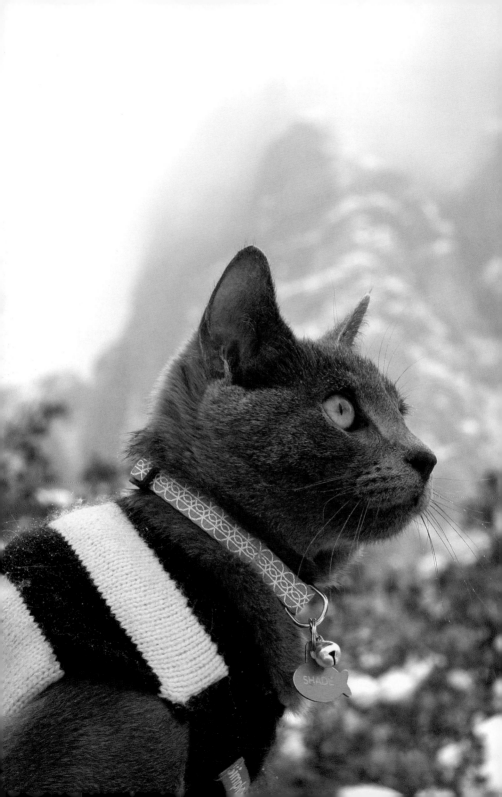

Soon, Shade was accompanying her humans on many of their climbing excursions. As long as it wasn't too hot and their destination was off the beaten path—and therefore not overcrowded and full of dogs—Shade was in tow. She'd explore the desert terrain and follow her human companions when they climbed.

Then, in December 2015, Avery, Anderson, and their feline family prepared to move across the country to Chattanooga, Tennessee. But just before the move, their oldest cat, a ginger tabby named Noaa, passed away unexpectedly. "He was my first pet as an adult, so he was very special to me," Avery says. "After we moved, I needed a

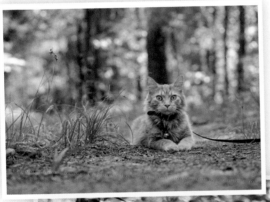

ginger cat in my life again. Noaa was so beautiful and spunky that I could not imagine another day without an orange tabby cat. I found someone on Craigslist who was rehoming their seven-month-old orange

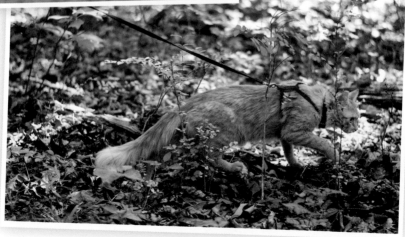

tabby mix. We picked Simba up and brought him home, and we could not picture our lives without him now. He is an amazing cat that brings so much joy."

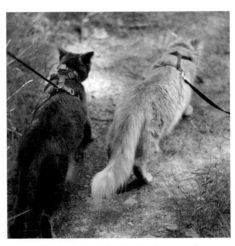

When Simba joined the family, he got a forever home and an adventure partner.

Shade and Simba bonded immediately and became more than just brothers—they became adventure partners. "Simba and Shade *love* each other and have paired well together," Avery says. "Adventuring with two kitties at once is quite a challenge, but since Shade and Simba get along very well, they have fun exploring together."

Adventuring with twice the number of tails and whiskers can be difficult at times, so Avery and her partner sometimes take the cats out one at a time. And lately, Simba has discovered a whole new way to explore the world: on the water. "Simba was the one we initially introduced to kayaking, and he was immediately intrigued with every aspect. He was curious about everything—so curious that he fell in the water a few times. Not to worry though. Simba is a good swimmer, and mom was able to assist in the rescue."

When it comes to adventuring with cats, whether on land or water, Avery says she's learned that it's certainly not for every cat. But if your feline friend enjoys exploring the outdoors and getting his paws wet, then it's definitely worth it. "The best part is being able to take your beloved pets on adventures with you. It's not fair that dogs get to have all the fun!"

MEET MILLIE, THE ULTIMATE "CRAG KITTY"

*F*ew felines have embarked on adventures as epic as Millie's. From exploring vast swaths of barren desert to scaling thousand-foot summits, Millie has done it all. But just like all adventure kitties, she got her start close to home.

Craig Armstrong adopted eight-week-old Millie from a shelter in 2013 and introduced her to a harness early on. "When she was a kitten I would put the harness on her in the house and just leave it on for a while," he says. "It was too big for her tiny frame so I crimped it smaller with some climbing tape, which worked well. Then sometimes I'd attach the leash cord to it and let her drag it around."

In addition to getting her comfortable in a harness, Armstrong also took Millie on frequent car rides to help her get used to road trips. And soon, the tiny black kitten was on her way to Salt Lake City's Liberty Park for her introduction to the great outdoors. "I started taking her to what I called Millie Island. In Liberty, there is a small pond that has an island reached by a little bridge. The island has a gazebo and some large old oak trees. I'd take Millie there and let her run around. All I had to do was guard the bridge. It was a good, safe entry to being outdoors."

Once Millie was comfortable roaming around her island, Armstrong took her to larger parks and more open spaces, where he taught her to follow him and keep pace as he wandered.

Millie often leads the way through slot canyons.

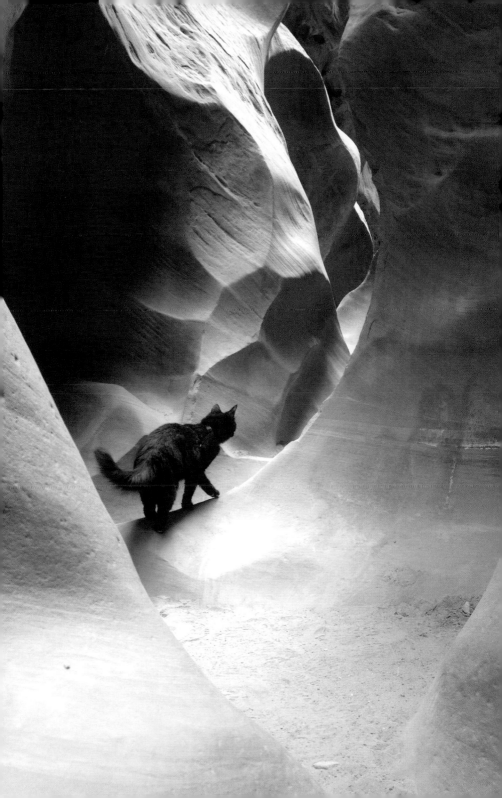

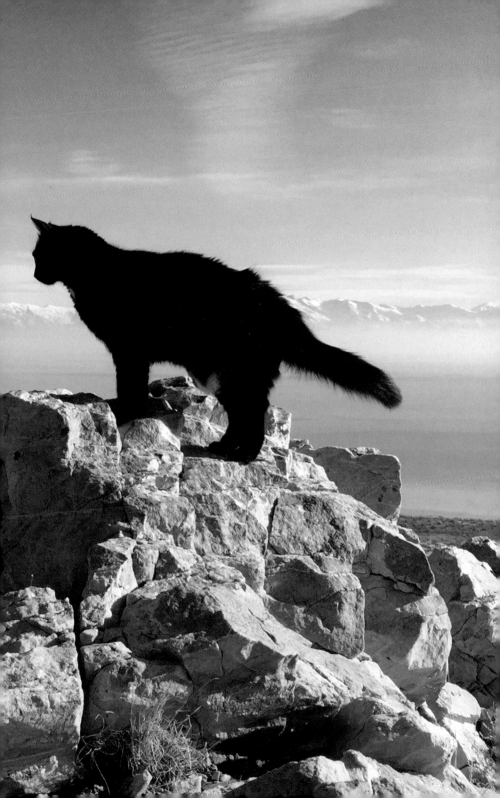

Soon he knew she was ready to join him for a climbing trip; however, things didn't quite go as planned. "People take their dogs to the crag all the time. I always knew when I got a pet I'd take my animal friend, too—it would just be a cat, not a dog. I took her to a climbing spot in Idaho, and there were a few other people

"Observe, protect, enjoy, and be led to new discoveries you likely would have missed otherwise."

and a few dogs and she really did not have a good time. So I realized if I'm going climbing for me, it's not good for her to bring her along. She does not feel safe around strangers or dogs outside in nature."

That's when Armstrong began planning a different type of outdoor excursion, one that was less about what he enjoyed and more about what Millie wanted. So he and his friend Zac Robinson—and Robinson's tabby cat pal, Kenneth—ventured into more remote areas

Armstrong defines "catting" as "putting your human agenda away, having no expectations or destination."

for laid-back days of bouldering and trips through slot canyons, narrow canyons that are deeper than they are wide. On these outings, Millie and Kenneth take the lead, and Armstrong and Robinson simply follow along, an experience that Robinson calls "catting."

"Your job is to follow, protect, keep safe," Armstrong says. "Your reward is experiencing nature at a slower pace, from a different perspective, in a new light. Observe, protect, enjoy, and be led to new discoveries you

likely would have missed otherwise."

Whether they're catting, climbing, or camping, Armstrong says safety is always a priority, and he keeps Millie's harness on even though he does occasionally let her off leash. "Millie is an indoor kitty," he says. "So when I take her on trips, I do not let her wander out of my sight. I am sure to give her plenty of time

to wander freely but I always keep her within view. There are just too many creatures that can harm a domestic cat in nature—coyote, fox, eagle, snake—so I am always there to keep her safe."

When asked what his favorite memory is of his adventures with Millie, Armstrong says it's impossible to choose. From scaling rock faces in Idaho to venturing into the remote Robbers Roost area of southeastern Utah, the daring duo simply have too many "ameowzing" escapades to choose from.

"We've sat on some pretty interesting perches gazing out at some beautiful vistas together. We've rappelled into deep slot canyons having no idea what obstacles are in front of us. We've summited multi-pitch climbs with some scary no-fall-zone moves involved. We've sat around campfires while she snuggles inside my puffy coat," he says. "It goes on and on—so many visuals, endearing moments, and pure joys. Every adventure is amazing and leads to more and more."

MEET YOSHI, A BOY'S BEST FRIEND

When the Schilling family heads out on an adventure—whether it's to the beach or into the Australian bush—their three-year-old tabby, Yoshi, is often in tow. And when they're at the lake, Yoshi is often quite literally in tow, because, believe it or not, this kitty loves to go tubing.

How did a cat end up riding the waves behind a boat? Kristy Schilling, one of Yoshi's owners, says his desire to tag along stems from the deep bond Yoshi has developed with the family. He's been by their side—both indoors and out—since the day he was adopted.

The Schillings have always been a cat family, and the cat they had when they were living in Canada had grown up with their son, Thomas. "We had every intention of bringing the cat with us for the move from Canada to Australia, but unfortunately he fell ill about six months before and had to be put down," Schilling says. "Our son was five at the time and was devastated, but after a few years of living here in Australia, and with the purchase of a new house, Thomas, then eight, was nagging us for a puppy."

Not long after that, Kristy and her husband, Peter, saw an adoption sign at their local vet. They went inside

"Yoshi took to the harness quickly when he realized it was his ticket to the great outdoors."

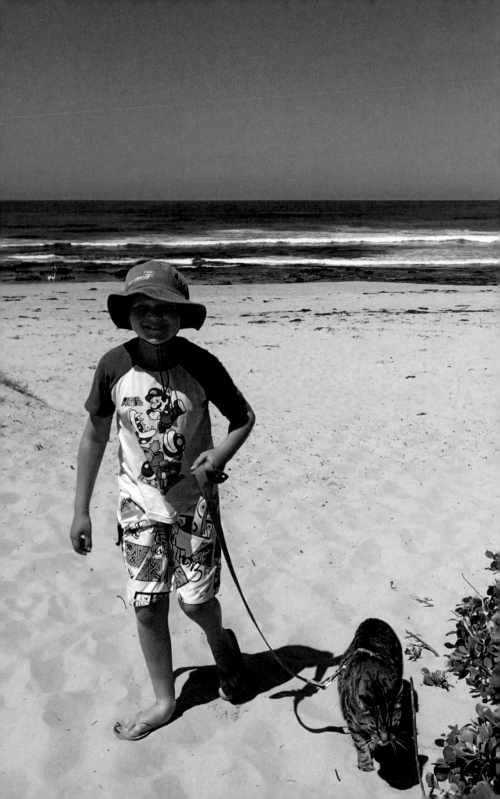

«‹«‹‹«‹«‹«‹‹«‹«‹«‹‹«‹«‹‹«‹‹«‹‹«‹‹«‹«‹«‹‹«‹«‹‹«‹«‹«‹‹«‹«‹«‹‹«‹«‹«‹‹«‹«‹‹«‹‹«‹

and spotted a tabby kitten huddled at the back of a cage. The tiny cat walked right over to them, and Schilling said they fell in love and decided to surprise Thomas with the new family member. "We brought him home, and our boy couldn't have been happier," she says. "Yoshi is very special because he ticks off the boxes on the list of why our son wanted a puppy: a pal to cuddle with and follow him around the house and play."

The Schillings knew that Yoshi would be an indoor cat because they wanted to protect the native birds, but they also wanted to include him when they spent time in the yard, so they purchased a harness and leash. Yoshi took to the harness quickly when he realized it was his ticket to the great outdoors. Most of Yoshi's first adventures were backyard ones, but

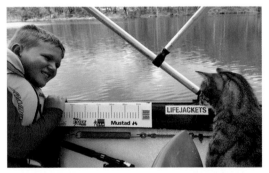

"My absolute, hands-down favorite part is seeing the joy it brings our son to have fun with his Yoshi," says Schilling.

when he was about a year old, the Schillings took him on a short trip to visit a family member and were thrilled to see how well he handled riding in the car. After that, they started including him on more outings, and Yoshi would look to Thomas to see how to behave.

"Yoshi takes on the same relaxed attitude that Thomas does," Schilling says. "If it's a bushwalk, Thomas is very quick to climb on logs and large rocks, and Yoshi will follow keenly. When we go on the boat, there is a lot of sitting, so Yoshi will once again follow Thomas and curl up and sleep. As long as he knows we are there, Yoshi kicks back and relaxes."

Tips for Tubing

In 2016, in the heat of an Australian summer, the Schillings were out on the lake in their fishing boat. Yoshi had long ago gotten comfortable on the boat and would simply curl up for a nap or watch his family as they fished and tubed. When they jumped in for a swim, he'd keep an eye on them from the safety of the boat.

"One particular day," Schilling says, "we had dropped anchor in a small, quiet cove at the lake and all three of us jumped in for a swim. This time, the tow tube was tied to the side of the boat, rather than placed on the roof, and Yoshi decided he would climb on in an effort to swim out to us without getting soaked. So Peter swam over and hopped on the tow tube with Yoshi and floated around a bit, and Yoshi cuddled in and loved it. So the next progression was to see if he would enjoy it with the boat moving—very slowly—and he did!"

Although Yoshi seems right at home on the tube, Schilling says they still take plenty of safety precautions. "Tubing is done with a human riding with him at very slow speeds and in an area without other watercraft—and near shore in the event he does decide to go for a swim."

Schilling says there are numerous benefits to bringing the family cat along for their outings—both on land and water. For one, they're more relaxed knowing their kitty is safe with them and not home alone missing them. And she says spending time in nature with Yoshi inspires the whole family to "slow down and notice the small stuff."

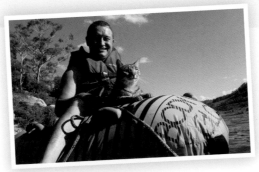

FROM BACKYARD TO BACKWOODS
HIKING AND CAMPING
WITH CATS

>»»»»►◄«««◄

THE FIRST STEP TO GRAND ADVENTURE: THE BACKYARD

For some cats—or their owners— adventures within the safety and comfort of their own backyard might be what they prefer. In fact, for many cats, staying in the yard may be best. In her book *Think Like a Cat*, feline behaviorist Pam Johnson-Bennett writes, "It'll be much safer because there's less chance of running into other

Remember to let your kitty explore the backyard at her own pace.

animals. Should your cat become upset or if you drop the leash, she'll be in more familiar territory in your own yard and you won't have to go far to pick her up and carry her inside."

But just because you're adventuring within the confines of your yard doesn't mean you can't have a grand adventure. There are a variety of ways you can enrich your cat's outdoor playground and engage with your pet in nature without ever having to leave your property. (For tips on how to create a cat-friendly garden in your yard, see page 195.)

Explore Together

While the backyard may not be an exciting destination to you, to a kitty who's never set foot outdoors, it's an exhilarating wilderness full of endless possibilities. It may take multiple outings for your cat to be comfortable enough to explore every corner of the yard, but once she's used to all those new sights, scents, and sounds, your feline friend will be leading you all around the property. After all, there's grass to sample, shrubs to crawl under, bark to scratch, dirt to roll in, and sun puddles to nap in.

HITTING THE TRAIL WITH YOUR CAT

I f your kitty is comfortable exploring the backyard or the local neighborhood, she may be ready to walk around a nearby park or even hit the trail. But first, ask yourself these questions to determine if your outdoor excursion is right for your feline friend.

What Kind of Trip Are You Planning?

A visit to a quiet park or a short nature hike in a familiar area? Purrfect. A little car camping with a tent nearby? Totally doable. A ten-mile backpacking trip or a few months on the Appalachian Trail? Your kitty would likely be happier staying home with a pet-sitter.

Is Your Destination Pet Friendly?

Leashed pets are typically welcome in U.S. national forests, but national parks have different rules. While some will permit pets on certain trails, they're typically not allowed in the backcountry. Do your research before you go, and keep in mind that some campgrounds will charge extra if you bring a pet.

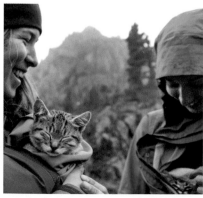

Be prepared to offer your cat shelter if the temperature drops.

How's the Weather?

Check the weather before you embark on even a short walk, and don't take your cat hiking or camping if temperatures are extreme. Also, consider the length of your cat's coat—or lack of coat—before heading out on a particularly hot or chilly day.

Tips for the Trail

Keep your cat on a leash.

Even if your feline friend never wanders too far and always comes when called, it's best to keep him on a leash—even if you have the trail all to yourself. When you're outside, you can't control the environment. Your cat could be spooked by a strange sound and dart away or be chased by an off-leash dog and scurry up a tree, so always keep the leash clipped to your cat's harness.

Stay alert and be prepared to pick up your cat.

Keep an eye and ear out for wildlife, dogs, fellow hikers, and anything else that may potentially frighten your cat. If you encounter anything he may consider a threat—even if it's simply an excited child—pick up your cat. Cats feel safer when they're up high and have the visual advantage, and you'll feel safer knowing your kitty is in your arms, on your shoulder, or perched atop your pack.

Walk at your cat's pace.

If you want to cover great distances or set a speed record, it might be best to leave your cat at home because when you're on the trail with your cat, the four-legged hiker is the one who sets the pace. Some cats may be comfortable walking for a few miles, but others prefer to simply go for a ride and enjoy the scenery. Give your cat a lift if she's tired, the terrain is tough, or if the weather starts to warm up. Your cat may love being outside but only want to explore every now and then, so make sure she's comfortably nestled in a pet-friendly backpack or perched on your shoulder.

As much as you may want to hike with your cat, keep in mind that many cats may never feel comfortable on the trail. Pay attention to your cat's body language and how she acts when you're out in the wilderness (see page 45). No one knows your kitty better than you, and you'll be able to tell if hiking simply isn't right for your cat.

If you're hungry on the trail, there's a good chance your cat is too.

Drink plenty of water.

Hydration is important for both you and your cat so bring along plenty of water—and be sure it's the water your cat is accustomed to drinking. Familiarize yourself with panting and other signs of dehydration (see page 81). Never let your cat drink from streams, creeks, ponds, or any other water you may encounter on your hike. It could contain parasites like *Giardia* or bacteria that can cause infections.

Take snack breaks.

Pack the exact same food that your kitty consumes at home to avoid any digestive issues. If you're camping, bring enough food for every day—and then pack a little extra just in case. Also, be a good parent and bring some treats to reward your kitty when he makes it to the campsite. If you're camping in bear country, remember that your cat's food goes in the bear bag (the weatherproof container you'll hang away from your campsite) at night too.

Stay on the trail and leave no trace.

Keeping to the marked path will help you avoid getting lost, prevent erosion of natural areas, and protect potentially threatened plant life. Always abide by the seven principles of Leave No Trace, which means packing and taking out all your trash—including kitty waste.

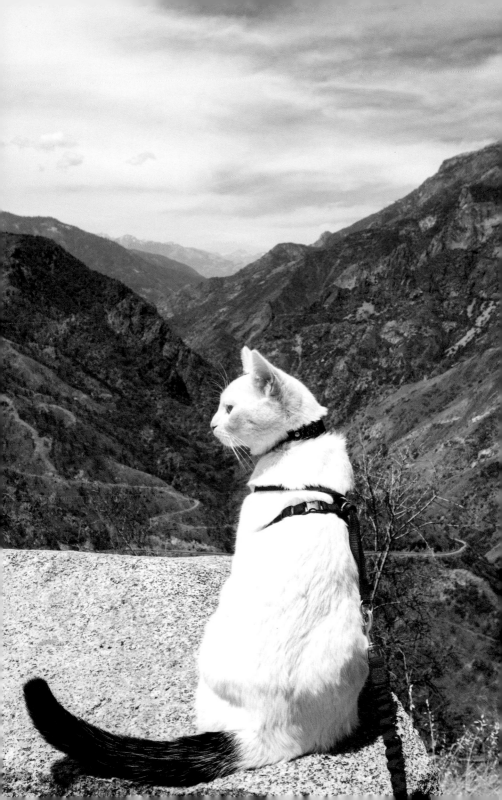

MEET QUANDARY, THE KITTEN WHO SAYS "I DO" TO ADVENTURE

*O*n May 23, 2015, Erin Shuee was hiking at the base of Colorado's Quandary Peak with her now-husband, Graham Shuee, when they encountered a mysterious basket on the trail. Graham immediately got down on one knee and opened the basket to reveal a five-week-old black-and-white rescue kitten and an engagement ring.

"He pulled off this grand scheme with some help from his friends," Erin says. "He admitted that he had no idea what we would do with another cat, but couldn't imagine proposing to his crazy cat lady any other way."

Naturally, she said yes.

Erin named the tiny kitten Quandary Q Lotus Lady, although she typically refers to her kitty simply as Quandary or Q. That very day, hiking alongside her newly engaged parents, little Q became an adventure cat. "We saw her being young and open-eyed as an opportunity to have her be our adventure cat," Erin says. "Our other two kitties were adult-adopted

> **"We saw her being young and open-eyed as an opportunity to have her be our adventure cat. . . . We immediately decided that Quandary would go everywhere with us."**

rescues and not as open to our adventures. We immediately decided that Quandary would go everywhere with us."

And go everywhere she did. Quandary joined her human parents in nearby parks for daily leash training and began to accompany them on short hikes. But Q soon had to take a break from her outdoor excursions when she "decided to show off her kitten parkour skills," according to Erin. One night at home, Q leaped from the dining room table—a leap that broke her tibia, landed her in a cast, and left her on cage rest for months.

Once she healed, though, Quandary was back to her outdoor adventures. "The best moments were those after she first got her cast off and had nothing holding her back on the trails," Erin says. "Cage rest was really tough after being so mobile, but [it was] absolutely necessary, and now you would never know."

Quandary made a full recovery from her injury and wasted no time in getting back on the trail.

Now that she's back on her feet, Quandary continues to hike, climb, and even accompany her humans to cat-friendly Colorado breweries. But Erin says that Q's absolute favorite activity is camping. "She loves watching the birds, bugs, and crackling fire, and she sleeps like a rock, snuggled in my bag with me at the end of the night."

And in June 2016, Quandary got to participate in a brand-new outdoor experience: a mountaintop wedding ceremony at Rocky Mountain National Park. The one-year-old cat donned a flower wreath and served as the flower girl in her humans' wedding.

When it's time for their new family to head out for a trip, the Shuees pack their kitty's bag, which includes collapsible bowls, food, toys, a litter box, and a Chilly Pad to keep Q cool if the temperature rises. And the sudden activity doesn't go unnoticed—Quandary shares in the excitement of the outdoor preparations. "Our hearts flutter every time Q walks up to the door and stands up on her back paws," Erin says.

During the car ride, Quandary

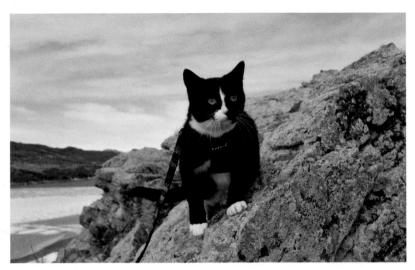

Even after her injury, Quandary isn't afraid to go "bouldering."

typically prepares by taking a catnap so she'll be full of energy when the hiking begins. While she's on the trail, the tuxedo kitty walks alongside her humans and climbs over rocks until she's ready for a break. Then it's time to hitch a ride in the backpack or atop Erin or Graham's shoulders.

"It really helps to have the flexibility provided with a pack," Erin says. "Being able to provide a comfy, safe space for whenever her paws get tired or there are one too many young pups out on the trail makes life much easier."

Erin admits there are disadvantages to hiking with a cat if you're focused on speed and covering lots of ground, but she says there are also incredible benefits to venturing into the great outdoors with your feline friend. "Hiking with your cat definitely keeps you humble, and therefore much more attuned to your surroundings; to slow down and soak it all in," she says. "Cats are such curious creatures that want to look closely at everything. We aren't taking her for a hike. Quandary is going for a hike, and we are lucky enough to be trailing her."

HOW TO ENSURE A HAPPY CAMPURR

With a little planning and preparation, you can make your cat right at home beside the campfire and in the tent.

The first thing to do is a test run at home. If your cat has never been in a tent before, it won't hurt to get him used to it. Set up the tent in your yard or even inside to let him get a feel for his new sleeping quarters.

Be Purrpared

In addition to all the standard camping essentials, be sure to pack these items as well:

Kitty carrier

You likely don't want to lug a large plastic carrier on the trail, so consider a soft-sided one that can collapse or lie flat. These more flexible carriers are great for camping because they provide a comfortable place for your cat to nap at night, as well as a safe place for your cat to retreat to. You may instead choose to have your kitty snuggle up in your sleeping bag with you at night, but keeping the carrier inside the tent is a good idea in case of an emergency.

Leash lights

Make sure your cat's harness and leash are outfitted with lights so he'll be easy to spot should he get away. Many adventure cat owners say that clip-on LEDs or bike lights do the trick. "When we camp there are small LED lights that we attach to our cat's gear," said Tomiina Campbell, whose two black cats often join her for camping trips in California. "Otherwise you can't see them on a dark night."

Litter box

While some cats have no qualms about doing their business in the woods, most cats prefer to have a litter box on hand, so be sure to pack a small one you can fit in your tent—along with your cat's usual litter (see page 78).

The comforts of home

Bring along a favorite toy or a familiar blanket to help your cat feel right at home in the tent.

At the Campsite

Have a plan for when you're setting up camp.

Never tie your cat's leash to something and leave him unsupervised. However, while you're setting up camp, Campbell suggests attaching your cat's leash to a nearby stake. "If we are car camping, the critters stay in the car until camp is set up. When we hike out, it's a bit trickier. So far we've only done hike outs with Kiva, and sometimes he will sit quietly waiting by the packs, and other times someone has to walk him around while the other person sets up the tent. When we're cooking meals, the cats are either in the tent or in our jackets, or their leads are tied to a stake in the ground."

When you camp with a cat, keep an eye on your kitty at all times.

Keep a close eye on your kitty.

From insects and plants to new scents and sounds, there's going to be a lot going on at the campsite that your cat will want to check out. Let him engage his curiosity, but do it under your supervision.

Watch that campfire.

Your kitty may be intrigued by the fire and want to check it out, so be aware of where he is in relation to it. While your cat is likely smart enough not to get close enough to singe his whiskers, he may not be aware of the location of his leash, so it's your responsibility to ensure that the leash doesn't get too close to where you're making s'mores.

Maintain your usual schedule.

Cats are autonomous animals, but just like us they can find comfort in ritual, so don't change your cat's schedule just because you're in the great outdoors. Feed your kitty at the same time of day, clean the litter box daily if that's what he's accustomed to, and climb into the sleeping bag at your usual bedtime.

Provide a safe place for your cat.

Whether it's a carrier or an open car door, your feline friend should have a place she can run to if she gets off leash or becomes spooked. "I think having the open tent door or the open truck doors, somewhere with familiar smells and what not, really helps [our cat] to relax outside and enjoy camping as much as we do," said Haley O'Rourke, who camps with her cat in Calgary, Alberta.

Remember that a cat can change the nature of your camping trip.

Keep in mind that there are drawbacks to camping with cats because it puts limitations on what you can do, and, as all good pet parents know, having your fur baby with you in the outdoors can cause a bit of anxiety. "I'd say the only disadvantage there is to camping with my cat is that sometimes I can't fully relax," said O'Rourke. However, cats can definitely enhance your outdoor experience. It can be magical to watch them interact with nature and downright comforting to have a kitty curled up on your lap beside the campfire.

MEET KIVA AND KLEO, TWO CAMP CATS

Although she lives in Los Angeles, Tomiina Campbell considers herself a "nature girl" at heart, so she jumps at the chance to stretch her legs on the trail or spend the night beneath the stars whenever the opportunity arises. And she and her husband bring the whole family along—including the cats.

Campbell first got the idea to include the cats in her adventures a decade ago when she saw a man in Helsinki, Finland, riding a bicycle with a "very happy cat on his shoulder." With L.A.'s traffic, she knew cycling with a cat was out of the question, but she couldn't stop thinking about a feline adventure partner. Then she met Kiva.

"As we walked in the shelter door and turned to look at the kitten corner, up from a furry black puddle jumped soon-to-be-Kiva who walked straight to his enclosure door," Campbell says. "After spending some time with the litter, it became quite clear this lil' guy wanted to know and do more. Bravery seemed to be a natural quality for Kiva. He didn't cower at the barking coming from the dogs in the next enclosure. In fact, he jumped up and looked right at them through the playroom glass."

Campbell says Kiva was "pretty much a kangaroo" during his first few months in his new home. He often snuggled in her sweater or rode in her husband's arms as they took walks around the neighborhood. Soon, Kiva was in a harness and walking on his own,

"It's amazing to see the world as a cat explores it," says Campbell.

and once he had all his vaccinations, he went on his first camping trip.

"He's awesome on our camping trips," Campbell says. "Kiva stays in camp nicely, spends the night in the sleeping bag, and lets you know when he wants tent time. Also, he never attacks the local wildlife— even a little vole is safe. He just watches them work for hours. Last summer, we took Kiva's biggest trip yet and tented around New England for two weeks visiting family. Kiva rode on the airplanes like a champ and adapted to each new place easily with his curiosity."

When the Campbells get ready to head out for an adventure, they say Kiva can always sense it's coming and "runs around like a happy squirrel in spring."

"Bravery seemed to be a natural quality for Kiva."

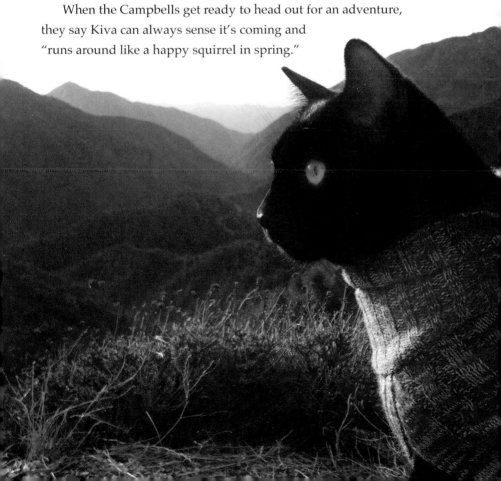

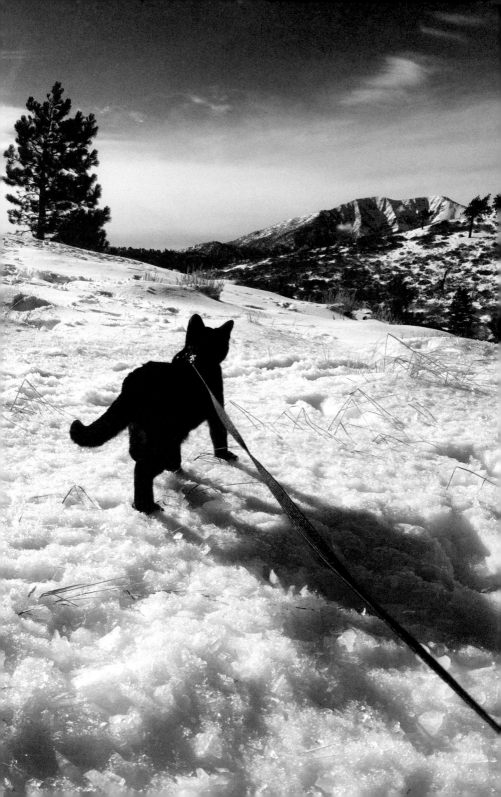

Once they get to the trailhead, Kiva typically rides in his backpack, enjoying the fresh air and taking in the scenery, but when they get to the campsite or turn around for the hike back, he likes to jump down and lead the way.

"He'll typically always walk any trail back from the turnaround spot," Campbell says. "It's familiar at that point and he wants to explore in detail what he saw on the way out."

These days though, Kiva isn't the only kitty on Campbell campouts—he now has an adopted little sister named Kleo. "Both cats' first camping trips were something amazing," Campbell says. "Their eyes! It is so clearly visible that their perspective has changed. Trees are for climbing. Birds are tangible things—not just colored darts flying past the windows. The nighttime is for prowling and listening to sounds unimaginable in the city. Everything is more alive in nature."

When it comes to planning a feline-friendly camping trip, Campbell says the most important thing is selecting a location, and she always looks for quiet, forested spots with lots of shade that aren't frequented by hikers. "Kiva doesn't like to hear other people when we're out camping, so the quieter the better," she says.

She also considers how long a hike they'll have to the campsite. So

far, they've only trekked in with Kiva because he's more accustomed to long walks outdoors. If you're just getting started with kitty camping, she recommends sticking with car camping. "Car camping at a quiet location that you trust is the best way to start off. Easy for everyone involved, and the

cats can stay in the car while you set up so they come to the campsite to find everything just right. It's glamping for kitties," she says.

Finally, she says weather always plays a role in whether Kiva and Kleo get to come along for the adventure, and during the summer, her adventure kitties always stay home with the air-conditioning. "It's too hot in Southern California for me, let alone a black kitty," she says. "One does have to seriously consider the weather with a fur baby along, so if it's too hot or too cold, the kitties stay cozy at home."

But when Kiva and Kleo do get to be campurrs, Campbell says it's an incredible experience, and she credits her feline friends with helping her find ways to connect with nature despite living in a large city. "Since adopting them, we have found more secret trails and hidden parks than I thought possible in a region with 17 million neighbors. It's brought Los Angeles into a whole new light for me and made this nature gal's city life oh so much better."

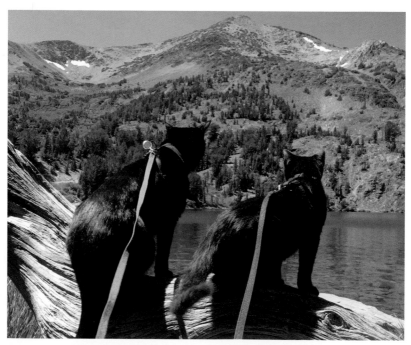

Kiva now has an adventure companion—his adopted little sister Kleo.

CATS ON THE HIGH SEAS

SURFING, SAILING, AND SWIMMING

>>»>»> ‹«‹«‹«<

DO CATS REALLY HATE WATER?

PADDLING SAFELY WITH PAWS ON BOARD

🐾 MEET NANAKULI, THE ONE-EYED CAT
WHO HANGS TEN

SAILING WITH CATS

🐾 MEET GEORGIE, THE SHIP'S CAT
WHO SAILS THE WORLD

DO CATS REALLY HATE WATER?

t's a widely accepted fact that cats hate water, but the truth is some cats actually enjoy dipping their paws into their water bowl or splashing in a running faucet. Believe it or not, some cats will even go for the occasional dip, and there are certain breeds that are known for their affinity for H_2O, such as the Turkish Van. In fact, its love of water has earned it the nickname "the swimming cat." With their naturally water-resistant fur, Turkish Vans are able to go for a paddle and emerge from the water with relatively dry coats. Certain other breeds, including Maine coons, Bengals, and Norwegian Forest cats, are also known for pawing at, splashing, and even swimming in bodies of water.

Cats are notoriously curious creatures, so it's no surprise they'd be attracted to water. Dripping faucets, rippling bathwater, and ill-fated toys that land in water bowls are all bound to get a cat's attention, and it's not uncommon for them to make a game of splashing in the toilet bowl or sticking their heads under the kitchen faucet for a drink. However, when it comes to actually being submerged, most cats consider swimming to be a spectator sport.

Of course, every individual cat is different. Your kitty may inherently love the water, or he or she may simply become accustomed to spending time in it, much like Nanakuli, the one-eyed Hawaiian surfer cat who became a natural in the water after receiving frequent baths due to health issues.

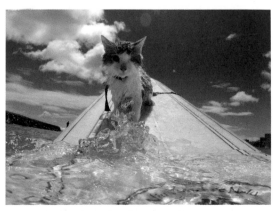

Nanakuli, the one-eyed surfer, proves that some cats are right at home in the water.

Can Cats Swim?

While certain wild cat breeds are known to fish in water or even bathe in it during warm weather, your average domestic cat is very different. Domestic cats descend from wild felines that lived in arid regions, and because swimming wasn't necessary for their survival, they didn't have to adapt or evolve to contend with water in this way. However, this doesn't mean cats can't swim—they're actually pretty decent swimmers. It simply means that cats aren't instinctively going to join you for a dip.

Just because a cat can swim doesn't necessarily mean he will.

Veterinary student Erin Dush, who hikes, camps, and paddles with her cat, Josie says, "It's a common misconception that cats can't swim. Josie swam to shore from my paddle board once and didn't seem bothered by it at all. I was there to jump in and help her if needed—which I did to help her get up on the dock—but she had no problem quickly swimming to shore."

Let your cat decide if and when she wants to get her paws wet.

Another reason cats often don't swim is because most breeds aren't gifted with the Turkish Van's special water-resistant fur, so getting wet involves taking on extra weight that can compromise agility. A wet cat is a vulnerable cat—he isn't going to stick around for a game of Marco Polo—he's likely going to run and hide.

Finally, cats are creatures of habit, and your kitty likely isn't in the habit of swimming. While your cat may enjoy observing running water or even pawing at it, this doesn't necessarily mean she's contemplating jumping in, so you should never "help things along" by placing or submerging your pet in water. After all, have you ever known a cat that liked surprises? If your cat is like most felines, a sudden noise, an unfamiliar visitor, or even a cruelly placed cucumber is reason enough for the fear response to kick in, so forcing your cat into water could be traumatic and make her fearful of it, the outdoors, or even you. If your cat encounters water either at home or on the trail, it's best to simply let her natural curiosity lead her to the water's edge . . . then let her decide if she wants to get her paws wet.

Not All Felines Are Landlubbers

Just because your cat has no desire to join you for a dip doesn't mean she won't be at home *on* the water. Plenty of adventure cats that would never willingly opt for a swim frequently join their human companions on canoes, kayaks, sailboats, and other watercraft.

A cat named Emma Deans frequently accompanies her humans on canoe trips around Alaska, and her owner, Nicole Gaunt, says the key to helping cats find their sea legs is to simply get them used to going on adventures. Before she set foot in the canoe, Emma Deans was already accustomed to walking on a leash and even leaping onto her owners' shoulders for bike rides, so while the canoe was a new experience, it wasn't overly daunting for the tabby. Gaunt admits that Emma Deans was a bit nervous at first and paced up and down the length of the boat, but it didn't take the feline long to jump onto a familiar shoulder and get comfortable. "Emma does great in the canoe," Gaunt says. "She'll either sit on the bow or ride on our shoulders—wherever she can get the best view."

Many adventure cat owners say their cats are so accustomed to paddling trips that they're not even fazed by a little H_2O. Mason

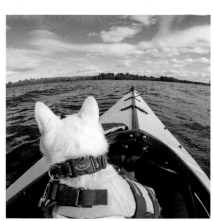

A boat or kayak is a way for cats to stay dry while enjoying the water.

Peters's cat, Ren, enjoys their canoe rides in British Columbia and either keeps a sharp eye out for flying insects or curls up under the seat for a nap. And Michigan resident Megan Yasick says her cat, Mango, is right at home in canoes and kayaks. "Mango is either boat cat captain or sleeping in the shade of the boat's walls," she says.

Erin Dush says Josie is right at home on the water as well, whether they're paddling in a kayak or atop a paddleboard. "Josie has always liked water from the tap and doesn't mind rain when we hike, so I didn't really think twice about putting her in the kayak the first time," she says. "She was initially nervous with the motorboats and waves going by but was soon sitting on top of the kayak with her tail dragging in the water."

PADDLING SAFELY WITH PAWS ON BOARD

Before you leave the shore behind with your cat in tow, be sure your feline friend is leash trained, accustomed to the outdoors, and comfortable wearing a flotation device (see page 145). Also, it may be a good idea to help your kitty acclimate to your canoe, kayak, or other watercraft within the safety of your home or yard. "Similar to going slowly and rewarding the cat as you would with initial leash training, I would recommend doing a few trial runs on a boat to see how the cat does," says veterinarian Dr. Amy Holford.

Don't place your cat in the boat until you're completely ready to go. This means having your own personal flotation device (PFD) fastened and all your supplies—including plenty of water for both you and your kitty—already aboard. Also, make sure your cat has a shady place in the boat where she can get out of the sun. "Often, there isn't much shade out on lakes or rivers," says Yasick. "We bring water, wet cat food, and a small battery-powered fan for Mango." Providing a shady crate or carrier that your cat feels comfortable in is also a good idea in case he gets spooked or needs a quiet place to rest. "It is important to have a safe place for a cat when taking it on a boat," says veterinarian Jennifer Stokes, who adventures with her cat Simon. "This could be a carrier or a backpack."

Pay attention to your cat's body language as you paddle (see page 45 for tips). Is she huddled beneath the seat with wide eyes? Pacing nervously? Standing comfortably at the stern with her tail twitching? Your cat may be understandably anxious during her first boat ride, but if she's accustomed to accompanying you on adventures, she'll likely soon be at ease and enjoying the ride. However, if your kitty appears nervous the entire time and doesn't seem to be adjusting, it may be best to head back to shore.

Also, it goes without saying that it's important to keep a close eye on your cat when she's out on the water with you. "Both dogs and cats have varying individual swimming skills and anyone of any skill can panic in cold or rough water," Dush says.

Use your best judgment when taking your cat out in a boat, and plan your trips carefully. Check the weather to ensure that it's a comfortable temperature for your cat. Dr. Stokes notes that wearing a life jacket may cause a cat to overheat in warm weather, which is why she takes Simon paddling only during cooler temperatures. If you're planning to embark on an all-day paddle, let your cat sit this one out. Remember that while she may enjoy a leisurely boat ride, she likely isn't interested in battling any rough water, so keep your trips short and easy when your feline friend is along for the ride.

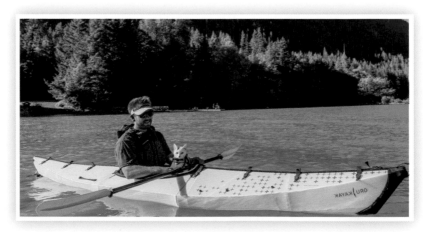

Do Cats Need Life Jackets?

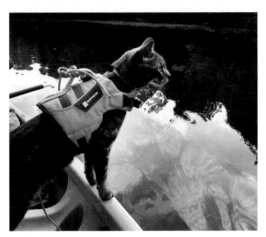

A life jacket is essential for a cat on a paddling adventure.

All boaters understand that it's important to wear a personal flotation device when they're out on the water, but when it comes to PFDs for cats, there's a lot to consider. Some sailors don't recommend strapping your cat into one because most pet flotation devices are designed for small dogs and may not fit a cat properly. Also, flotation devices may interfere with a cat's agility if the animal isn't accustomed to wearing it. However, Dr. Holford says life jackets are an essential piece of boating equipment for felines as well. "Just as with people, life jackets while on board any vessel are a must. They can easily be purchased at most pet stores and online."

Luckily, many boaters say their cats have no problem adjusting to life jackets, especially when they're already accustomed to wearing a harness. When purchasing one for your cat, ensure that it's a comfortable fit and will stay on should your kitty go overboard, but isn't so tight that it would restrict her movement. The jacket or vest should also have a handle on the back between your pet's shoulder blades so you can lift your cat out of the water by hand or with a hook. Remember that a flotation device can be a lifesaving piece of equipment only when it's fitted properly and when your cat has had time to adjust to it.

MEET NANAKULI, THE ONE-EYED CAT WHO HANGS TEN

Before Nanakuli was catching waves and hanging ten—even before the handsome kitty was born—his owners, Krista Littleton and Alex Gomez, were talking about him. "Almost a year ago, over waffles, Alex was explaining one of the many translations for the name Nanakuli," Littleton says. "Nanakuli means to look blind. Alex joked about getting a one-eyed orange cat and naming him just that."

Not long after that fateful breakfast conversation, Littleton and Gomez, who are roommates and special-education teachers on the Hawaiian island of Oahu, found a kitten that fit this description through a local nonprofit. The three-month-old kitty had been found in an area of Oahu named Nanakuli, coincidentally enough, and was about to have an eye removed due to infection. Naturally, Littleton and Gomez adopted the tiny kitten—who weighed in at just under a pound—and named him Nanakuli, or Kuli for short.

Kuli had been found on the street and was extremely malnourished, so it took him a while to recover from his eye infection. "In the first month we were concerned that our new friend was not going to make it," Littleton says. "We think part of the reason Kuli is so tolerant of water is because he had to have frequent baths due to his messy health issues."

Once Kuli was recovering, Littleton and Gomez slowly began integrating him into their active island lifestyle. Before letting him leave the house, they trained him to walk on a leash and then moved on to short walks around the neighborhood. Once he was comfortable exploring the outside world in his harness, it was time for Kuli to see the ocean. "As his health improved we regularly took him to a quiet beach in an animal carrier," Gomez says. "We always left the door of the carrier open for him to decide when he was ready to come out and explore or when he needed to go back in for a safe place to regroup."

Because Kuli was already pretty comfortable in water, Littleton and Gomez decided to introduce him to the ocean. They fitted him with a life jacket and placed him atop a surfboard. "His first time in the water we just let him float on the board by himself near the

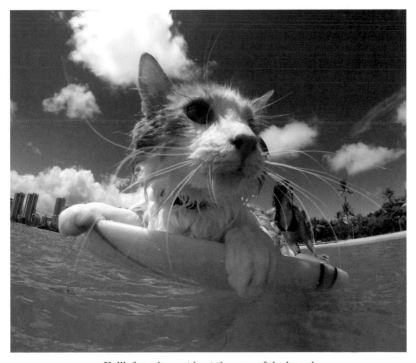

Kuli's favorite spot is at the nose of the board.

shoreline," Gomez says. "Then I paddled around with him, not yet in search of waves. Before we knew it we were paddling out to actual surf breaks in Waikiki."

Littleton says her favorite memory of Kuli is the time he rode his first wave. "We had been having so much fun playing around in the ocean and training him. Our hopes were really high that he would like surfing, and we really got lucky because he just lies right on the nose of the board with his paws hanging ten."

For a while, Kuli accompanied Gomez on nine-foot to ten-foot longboards, but when she realized that Kuli liked the spongy material of boogie boards, Littleton purchased an eight-foot Wavestorm foam board. Now, Kuli joins Gomez and Littleton on almost all their outdoor excursions. "As soon as you grab the leash you can hear him purr," Gomez says. "He usually shows he is ready to go when he climbs into the beach bag."

When they arrive at the beach, Kuli does about an hour of surfing with Gomez, and Littleton comes along to document his "pawsome" surf skills. "I am not great at surfing, so I spend more time with some fins on, swimming around with my GoPro to try and photograph all of Kuli's adventures," she says. "I have always loved photography, and naturally, Kuli is a lot of fun to take photos of, especially in the water."

But even though Kuli is now an experienced feline surfer, Gomez says safety is always a priority. "Before Kuli could confidently swim on his own, he always wore a life jacket. He still wears a life jacket

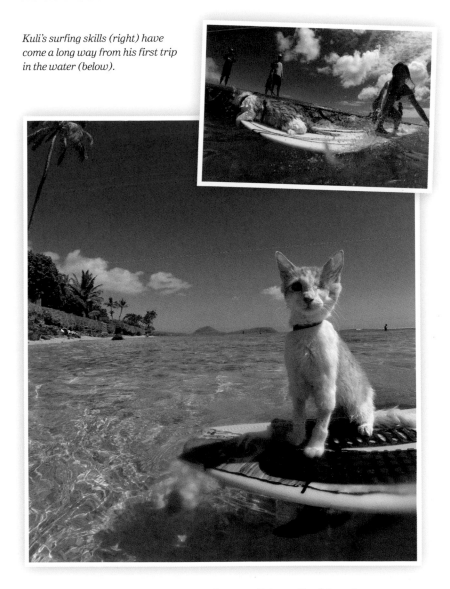

Kuli's surfing skills (right) have come a long way from his first trip in the water (below).

from time to time, depending on the conditions. For his safety, we are cautious and take him out only when we know it will not be too hot or too windy, or if the water is too rough. Fortunately, in Hawaii, the conditions are usually in our favor."

SAILING WITH CATS

Cats have a long history on the high seas. Known as ship's cats, seafaring felines have sailed aboard trading, exploration, and naval ships dating back to ancient times. The chief duty of ship's cats was pest control, and they easily adapted to life at sea, catching the rodents that threatened vessels' ropes, woodwork, food, and cargo. Today, ships' cats are still around; however, they're more likely to be spotted lounging on decks than earning their keep as mousers. In fact, many cats have only ever known a life at sea.

Think your kitty has what it takes to be a ship's cat? If so, read on to prepare your feline friend for adventures as a first mate.

When the boat rocks, Georgie keeps her balance by swaying her body side to side.

Kitties Have to Find Their Sea Legs Too

Just as it takes you some adjustment to walk around a moving vessel, it might take your kitty some time too, especially when the waters are rough. Jessica Johnson's cat Georgie, a four-year-old gray tabby, has lived aboard a boat since she was six months old, and Johnson says Georgie manages even choppy waters like a pro. "She handles rough waters really well and seems very in tune with the motion of the boat.

Seasickness Happens

Seasickness can be a problem for cats just like it can for humans, but seasoned sailors say that pets can adjust to the motion of the ocean just like we do. Louise Kennedy says her seal point Siamese,

Bailey, occasionally gets sick, but only when they return to sea after a lengthy stay in a marina. Luckily, it doesn't take Bailey long to recover. "We comfort him and encourage him to get some fresh air in the cockpit, which, like humans, helps him feel better," Kennedy says.

If your cat is prone to motion sickness (see page 57), you can talk to your veterinarian about medication before setting sail.

Know Where Your Cat Is at All Times

The best way to prevent a kitty falling overboard is to keep an eye on him and have a policy for where your cat will be, both when you're sailing and when you're at anchor. If you allow your cat to roam the deck while you're moving, be sure he has his life jacket on. However, most sailors say if they're at sea, their kitty companions are either below deck or safely on a leash and tethered nearby within view.

"Our biggest safety precaution for Georgie when we're traveling is to make sure to keep her on the boat," Johnson said. "At anchor, she is free to roam the boat and deck without a leash or life vest. During passage, she is wearing her harness and leash 100 percent of the time. If she is in the cockpit, we attach the end of her leash to a cleat near the companionway (the entrance to go below deck), and it's not long enough for her to reach outside the cockpit."

Be Prepared in Case Your Kitty Does Go Overboard

Despite their impressive balance and agility, cats can go overboard, so be prepared. Keep a long-handled fishing net on board in the event that you ever have to fish a cat out of the water, and it's also a good idea to attach a ladder or another easily climbable device to the side of the vessel so your cat can crawl up. Kennedy says if Bailey ever goes for a swim, he knows just what to do. "Bailey has been trained to use a rope ladder to climb up if he falls in while we're at anchor,"

she said. Some sailors use rope ladders or regular steel ladders, but others say they've attached towels or strips of carpet to the sides of their boats so unlucky kitties can crawl up in the event of an emergency.

Luckily, most sailors with kitty companions say an overboard cat is a rare occurrence. Some say their cats have never taken a plunge, while others say after it happened once, both they—and their cats— learned to take further precautions. "Although there are adventure cats out there who might stare over the side of the deck with curiosity while the boat is moving, most will try to find an out-of-the-way spot to hide until the boat is still again," Johnson said. Dush agrees, noting, "Cats are generally more agile and skilled at balancing than dogs and less likely to fall in."

Create Kitty-Friendly Areas

If your cat will be spending time below deck while you're at sea, secure any objects that could fall or bounce around while underway, and be sure to provide your cat with everything he may need— including a litter box. To prevent spillage, opt for an enclosed litter box that fastens tightly and be sure to situate it in a secure area. Johnson and her husband use a custom-made litter box fashioned out of a Rubbermaid container. Also, keep hooks, lures, and other fishing gear in a secure place where curious kitties can't investigate them. "Anticipate that anything fishy smelling or on fishing lines is going to attract a cat and should be kept out of their mouths and off their paws," said Dr. Holford.

Be sure your cat has a place of his own where he feels comfortable and can curl up for a nap. "If we're sailing, Bailey wedges himself under the navigation table or in the bathroom cupboard, and to sleep he has his own sheepskin bed on top of the wardrobe," Kennedy says.

Do Your Research—and Your Paperwork

Before you enter any country (whether by car or boat), check the nation's pet policies and regulations and ensure that you have the appropriate documentation. Some countries may require only an up-to-date health certificate, but others may want to see more extensive paperwork, including medical tests or even notarized forms from the U.S. Department of Agriculture. And even if you're not planning a stop in a nearby country, Johnson says it's still a good idea to do some research and be prepared in case of an emergency. "When we sailed to Bermuda we never planned on stopping (on the island), so we hadn't checked their regulations, but a hurricane a few hundred miles from us forced us in," she said. "It turns out we did not have the proper paperwork necessary to clear Georgie in, but since she is a cat, they let the two of us check into the country and promise we would anchor the boat and not let Georgie go on shore— one big benefit of a cat over a dog."

MEET GEORGIE, THE SHIP'S CAT WHO SAILS THE WORLD

In 2012, Matt and Jessica Johnson quit their jobs, sold their house and their cars, and took to the sea in their refurbished boat—but their crew wasn't quite complete. They wanted a furry friend to keep them company during their ocean voyages, so when they were anchored in St. Mary's, Georgia, they made a stop at a local animal shelter. That's when they met Georgie. The six-month-old tabby needed a home, and the Johnsons needed a kitty captain, so it was a "purrfect" match.

"Because she had just come from a shelter with such little human interaction, she was like our shadow for the first week or so, never leaving our sides or our laps," says Jessica. But soon, Georgie had found her sea legs and made herself right at home on the boat. She took up bird-watching and began supplementing her kibble diet with fresh fish. And she even found a comfy place for catnaps—atop the first aid kit in the main salon—and claimed it as her own.

The Johnsons say safety is a priority aboard their boat, so Georgie dons her life jacket during nighttime passage, and she's allowed to roam the deck unleashed only when they're at anchor. They also keep a ladder on the side of the boat so Georgie can easily climb back aboard if she happens to fall in—which, luckily, has happened only once. "It happened one time in Mexico, and we were extremely happy

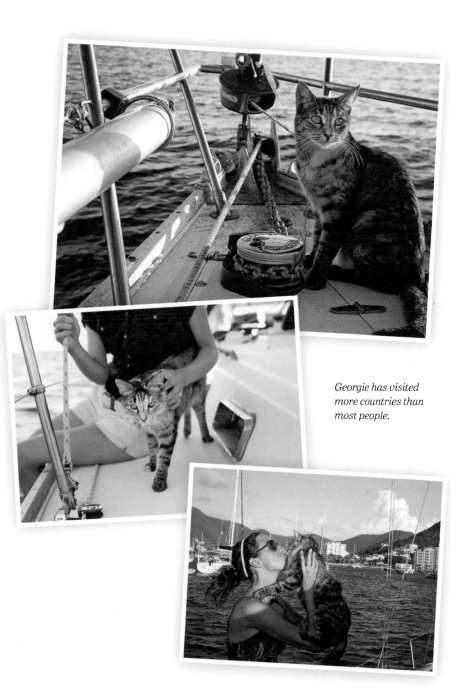

Georgie has visited more countries than most people.

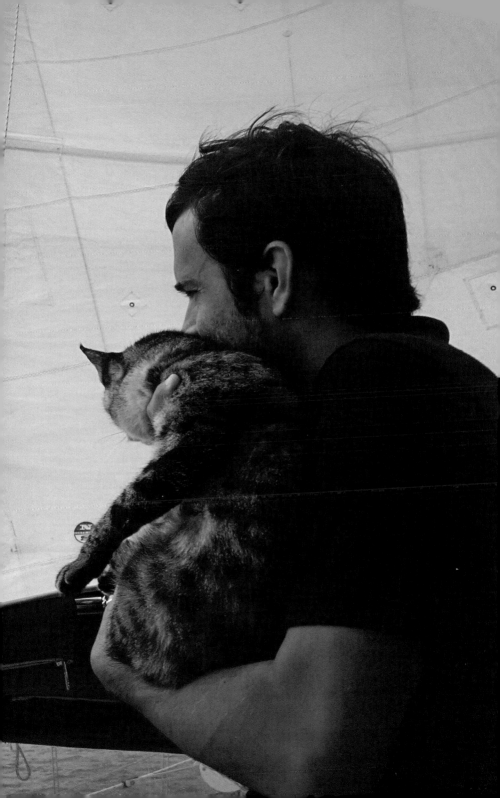

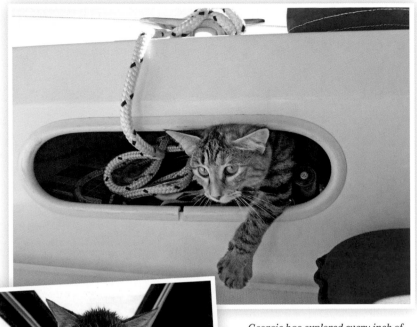

Georgie has explored every inch of her home on the ocean.

and proud that she was able to get herself back on board," Jessica says.

Georgie is actually quite the swimmer. While she was in the Cayman Islands, she did some supervised swimming alongside her human companions and easily outswam Matt.

Georgie has now sailed to more than sixteen countries. The seafaring feline's favorite stop so far? Isla Mujeres, a Mexican island in the Caribbean Sea. "We spent about seven weeks there at anchor, and in the mostly clear water there would always be vast groups of minnows swimming by the boat and little needle-nose fish trying to

catch them," Jessica says. "Georgie would sit and stare at them for hours, as well as the seagulls constantly flying by."

While Georgie enjoys watching the local wildlife and snacking on the catch of the day, for the Johnsons, the best part of life on the sea is sharing the experience with their furry, fish-loving companion. "Our favorite thing about having Georgie on board is an extra element of entertainment and companionship—and someone to talk to while the other person is sleeping on passage," Jessica says. "Sailing with her has taught us that cats can absolutely be introduced to life on the water, and for the most part, will tend to enjoy it immensely. Georgie is a wonderful travel companion, and we could not imagine our lives or adventures without her there with us."

Think your kitty would love the life of a ship's cat? The Johnsons offer these words of advice before taking the plunge: "Ease your cat into the lifestyle. Let them get familiar with the boat before you take any big sails, and try for short passages at first."

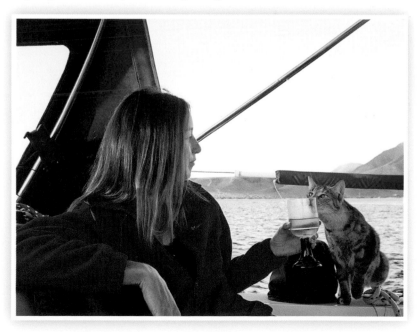

PAWPRINTS IN THE SNOW
WILD WINTER ADVENTURES

>»»»> ‹‹«‹‹‹

CAN CATS VENTURE OUTDOORS IN WINTER?

🐾 **MEET JESPER,
THE NORWAY KITTY WHO SKIS**

**MAKING THE MOST OF
WINTER WEATHER "CATVENTURES"**

🐾 **MEET RUGER, AKA "THE SNOW KING"**

CAN CATS VENTURE OUTDOORS IN WINTER?

When fall approaches and the temperatures dip, many adventure cats can finally journey outside again comfortably, but as the mercury drops lower and snow blankets the ground, it may be time to bring the adventures back indoors again (see page 190 for

(see page 190 for tips on indoor adventures). Many cat owners say their adventures simply become shorter during winter months and they stick closer to home—a quick walk around the neighborhood or some backyard exploration is enough to stave off the cabin fever. And some cat owners in particularly cold climates say they simply put the adventuring on hold until the spring. But, of course, it depends on the cat.

"Sirius handles snow great," says Johanna Dominguez, who hikes with her Savannah cat, Sirius Black, in Buffalo, New York. "Sirius especially loves to adventure in the backyard when it has snowed. He also likes to go out on forest walks and around the neighborhood. The first time it was snowing outside, he kept looking up and shaking his head when some tickled his whiskers.

A little snow isn't going to keep Sirius Black indoors.

But the next time he encountered snow, there was a lot more, and he responded by digging and trying to catch the snowflakes. The snow definitely doesn't slow him down."

"Cats react differently to cold, and some can resist more than others. Some breeds have enough fur and can be outside in the winter with supervision," says Aina Stormo, whose long-haired cat, Jesper, enjoys exploring the Norwegian countryside in winter. "Jesper has extremely heavy fur, so he doesn't like the summer temperatures as much as we do. He is used to the winter season."

But determining whether a cat will be comfortable in cooler temperatures doesn't depend only on the thickness and length of their fur. Other factors, including health, age, and body mass, also play a role, and just as some people tolerate cooler temperatures better than others, the same goes for cats. Kittens, elderly cats, and felines with heart disease, diabetes, kidney disease, or other health issues may have a more difficult time regulating their body temperature, and they're also more susceptible to

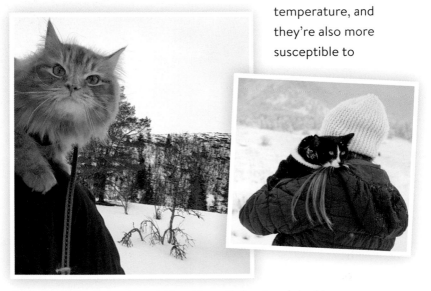

Jesper and Quandary enjoy catching rides on their owners' shoulders.

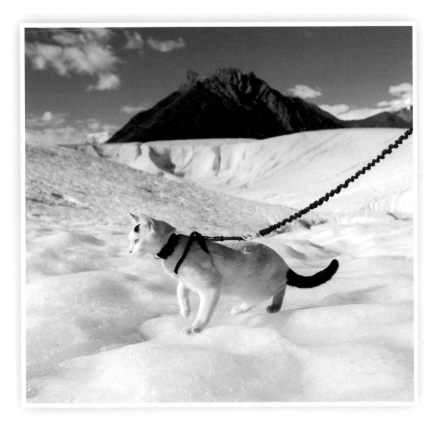

complications from extreme weather. Consult your veterinarian to learn more about how your cat may tolerate cold temperatures.

"Overall, I would leave it up to each individual cat to see if they want to be in the cold weather," says veterinarian Amy Holford. "If they seem to enjoy it, then go for it." If you decide to attempt a winter adventure, follow your cat's cues. If she shows no interest in going outside—or if she exhibits signs of discomfort when you first venture into the cold—save your kitty outings for spring. If she thinks cold-weather activities are the best thing since canned tuna, then see page 170 for some guidelines on keeping your kitty safe, healthy, and happy all winter long.

MEET JESPER, THE NORWAY KITTY WHO SKIS

ost cats wouldn't choose to venture outside in frigid temperatures to trample through snow, but Jesper isn't most cats. The three-year-old long-haired mixed breed lives in Norway, and he not only enjoys winter, but prefers it to the summer months. "He looks happiest when it's not too hot," says his owner, Aina Stormo, who adopted Jesper in October 2013 when he was just three months old. "Jesper started his outside life in wintertime before he experienced the other seasons, so he thinks the winter is quite normal."

Jesper began accompanying his human family outdoors for leashed walks at a young age, and when they traveled the country for sporting competitions, he tagged along as well. It didn't take the Stormo family long to realize that there was no activity Jesper wasn't up for—even skiing. During winter, much of Norway is covered in snow, but a few feet of powder isn't going to keep Jesper inside. Instead, he trots alongside or ahead of Stormo as she cross-country skis, and if the path gets difficult or the weather too chilly, Jesper hops into his backpack.

Stormo says feline-friendly skiing can be difficult, but Jesper enjoys it so much that she's compelled to bring him along. "It is not so easy to go skiing with a cat," she says. "You have to be good at stopping fast, and you have to have good balance. Jesper mostly wants to walk in the track.

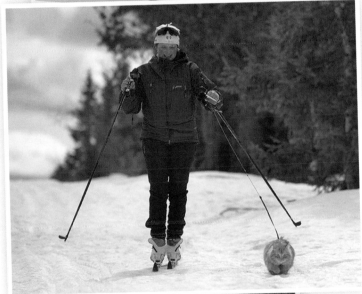

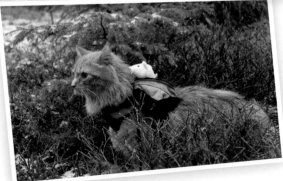

With his long, warm coat, Jesper is well suited to outdoor winter adventures.

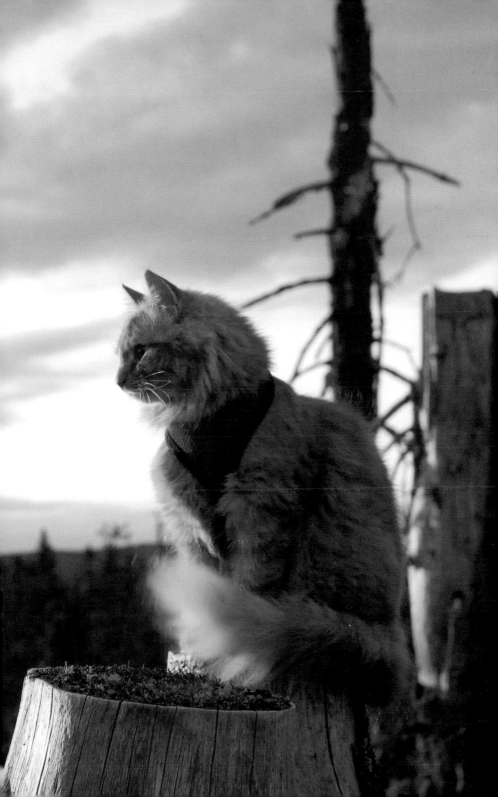

That's easier for him, but difficult for me. But he is little, so I do what's best for him. He can't run fast downhill, so he sits in the backpack or on my shoulder."

If it's particularly cold or windy, Stormo leaves Jesper at home, and when they're out in the snow, she keeps a close eye on her skiing companion and continually checks to make sure he's not at risk for frostbite. "Jesper has plenty of winter fur, but sometimes he can get cold on the feet or ears," Stormo says. "From about −15° Celsius (5° Fahrenheit) we need to start checking his ears and snout, although most of the time he lets us know if he thinks it's a bit cold by jumping in his backpack. In the backpack, he has a bottle with hot water and a wool blanket, so he is snug and warm. He loves the backpack so much that sometimes he falls asleep there." When they get home, she always checks Jesper's paws to ensure they're not dry or cracked.

In addition to his winter ski trips, Jesper also enjoys hiking, swimming, tracking scents, and riding in bicycle baskets, but Stormo says Jesper's absolute favorite activity is fishing. "Fishing trips are heaven for him. Some of our best memories involve fishing trips in the evening. It's dark, we make food on the campfire, and he sits with us."

But while Jesper's love for adventure has inspired many people to compare him to a dog, Stormo is quick to point out that Jesper is a cat—and that means he isn't going to do anything he doesn't want to do. "A cat is a cat—not a dog," she says. "If Jesper doesn't want to walk, he really *doesn't* want to walk. There is no discussion. Then he jumps into the backpack and sits there with a happy smile on his face."

Stormo says Jesper is her "best buddy in fur."

MAKING THE MOST OF WINTER WEATHER "CATVENTURES"

Shorten Your Walks

Just as you're sensitive to temperature and susceptible to frostbite and hypothermia, so is your cat. The best way to protect both yourself and your kitty is to limit the amount of time you spend outside in extreme temperatures. So keep the walks short and close to home and save the camping trips for spring, especially if you live in a particularly chilly climate.

Try to Stay Dry

While some cats may enjoy romping, digging, and rolling in the snow, keep in mind that wet fur makes it harder for cats to stay warm, so try to avoid deep snow and limit the snowy playtime. "Simon *loves* the snow, but I would never take him outside if it was below freezing," says Dr. Stokes. "I've let him outside for up to fifteen minutes in the snow. There are many factors to consider. Is the snow wet? Is there much wind? Can the cat get out of the snow? A wet pet is more likely to get chilled. If it is dry and there is no snow, there is less risk of a pet getting chilled."

"If Jesper is walking too long in snow, his fur will get full of snow, which isn't good for him. So I always have a backpack with me so he can rest in there," says Stormo. "We also always walk in ski tracks. Do not let the kitty walk and struggle in heavy and deep snow—they do not like it, and it's unsafe."

Consider Clothes—but Don't Force It

We prepare for cold weather by adding extra layers, and cats bundle up in their own way by growing a thicker coat in winter. While cats don't typically require a sweater to stay warm, hairless breeds or

kitties without much of a naturally thick coat may benefit from an extra layer. However, as cute as they may look, most cats aren't interested in playing dress up—clothing can be uncomfortable, and it could possibly cause overheating. "I did initially try dressing Sirius up in outdoor gear, but it hindered his activity, so I stopped," said Johanna Dominguez. Dr. Stokes acknowledges that some cats may benefit from donning a coat, but that if you think your cat needs clothes to stay warm, she's better off just staying inside. "Most cats do not need coats or booties," she said. "If it is very icy, they would likely benefit from booties, but I wouldn't take my cat out under those conditions."

Quandary is comfortable in her winter sweater, but not all cats enjoy wearing clothes.

Clean Those Paws

Cats are meticulous groomers, but if your feline friend ventures outside in winter, you need to be the one to clean her paws once you're back inside. Salt, deicers, and other chemicals are often used outdoors during winter, and they can irritate paw pads and be

potentially lethal if ingested. When your adventure is over, check your cat's feet for cracks, redness, or irritation and wipe her paws with a damp towel. You may also want to wipe down your cat's belly, especially if she has long fur. Consider using pet-safe deicers on your property, and if you suspect your cat has ingested chemicals or any dangerous substance, see a veterinarian immediately. (See page 86 to learn more about poisoning in cats.)

Watch for Signs of Frostbite and Hypothermia

Despite their fur coats, cats are still vulnerable to cold temperatures, especially when they're wet. If your cat is shivering, or if she seems lethargic, slows down, or stops moving, bring her inside to warm up immediately. Cats' noses, ears, tails, genitals, and paws are especially susceptible to frostbite, which results from prolonged exposure to severe cold. Frostbitten areas will appear pale or gray in color and will be red and swollen once the animal warms up and circulation returns to the affected areas. If you suspect your pet has hypothermia or frostbite, consult your veterinarian immediately.

Never Leave Your Cat in a Vehicle

Whether you're running errands or heading out on a road trip, never leave your cat unattended. Just as cars can trap heat during the summer, they can act as refrigerators during winter, holding in the cold temperatures, which can cause hypothermia or even death.

See a Veterinarian First

A veterinarian should examine your cat at least once a year. Cold weather may worsen some medical conditions, so during the checkup, ask your vet if your cat is healthy enough to be venturing outside during the winter months.

Use Your Best Judgment

Don't assume that your kitty's fur coat—even if it's long and thick—will keep her warm. If you're uncomfortably cold when you step outside, the odds are your cat will be too, so it's best to keep her at home. "Generally, I find that if I can go out and hike without bundling up too much, then it's safe to take Josie," says Erin Dush, Josie's owner. "But I think the biggest factor to keep in mind when adventuring with cats is to put their well-being first. They trust us and our judgment, so we should keep this in mind as we bring them along with us. While I would love to have Josie with me on every adventure, I realize that sometimes it's not in her best interest to go in the extreme weather, so I leave her behind. Plus, it just gives me an excuse to go adventure another time when the weather is milder."

"The biggest factor to keep in mind when adventuring with cats is to put their well-being first."

MEET RUGER, AKA "THE SNOW KING"

Michigan's Upper Peninsula is known for its long, snowy winters, but no amount of snow keeps Ruger indoors. The two-year-old black-and-white cat has been romping through powder ever since his owner Kim Randolph adopted him in May 2015.

When Randolph first laid eyes upon Ruger, she didn't think she was ready to adopt another pet. Her cat Angus had recently passed away, and she was heartbroken. But when Ruger and his litter came to the shelter where she worked, Randolph said she felt an instant connection to the kitten. "There was just something about that little cat that felt familiar, exciting, and right," she says. "I let him go home with his foster dad and siblings for the evening and really thought it over. I knew he had to be mine when I couldn't sleep that night. So, first thing in the morning, I called his foster dad and told him that I'd love to be that kitten's new parent. He brought Ruger in to work that afternoon, and it's been nothing but perfect since then."

Ruger's outdoor adventures began when he'd accompany Randolph and Jeremy Vick, his new parents, onto the porch while they grilled, but soon he was donning his harness and venturing farther from home. He explored nearby parks, hiked the trails of local recreation areas alongside his German shepherd pal, Zoey, and curled up in Randolph's hammock along the shores of the lake.

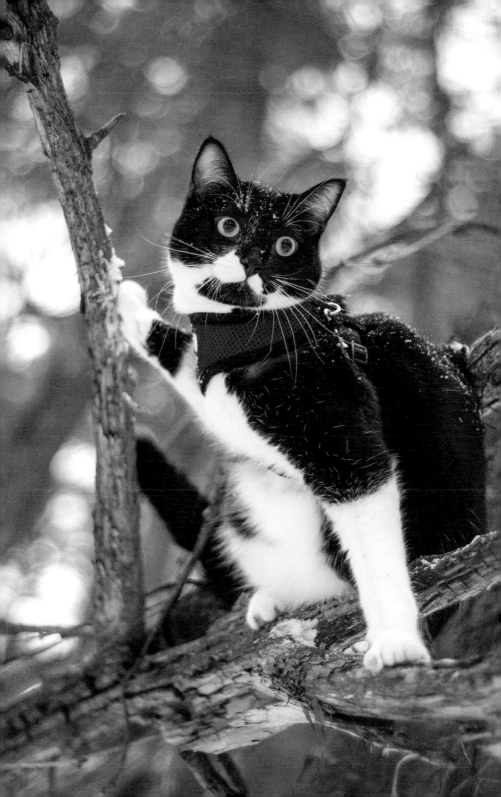

As long as it's not too cold, Ruger gets to join his family on their snowy treks.

He was only twelve weeks old when he first encountered snow, and while he wasn't sure what to make of it at first, Ruger soon became a winter weather pro. "We had a late May snowfall the year I adopted him, so I took him out just to experience it," Randolph says. "Once he was older and able to walk some distances on his own, I took him out again and he was a natural."

These days, Ruger spends Michigan's chilly winters romping through the snow—but if the temperature dips too low, Randolph says her adventure cat has to stay home. "I only take Ruger out when the temperature is warmer — between twenty-five and thirty degrees, with low winds. If it is too cold out for my face to be uncovered, then it's too cold for Ruger."

And when they're outside in winter, Randolph always has a backpack on hand so Ruger can get out of the cold and snuggle up in a blanket if he needs it. "My favorite snowy memory with Ruger is when we took him out snowshoeing with us," Randolph says. "It was a mild winter day, which is hard to come by in upper Michigan. At first, he was unsure of the snowshoes because they were big and loud

when crunching the snow. For most of this trip, he rode in a warm backpack, but he loved getting out to cuddle with Dad and explore at the rest stops along the trail."

Randolph says there are many things she appreciates about adventuring with Ruger, especially the slower pace he requires, which forces her to take her time and notice details in nature that she would've hiked right past before. But she says her absolute favorite part of their adventures is the conversations Ruger inspires with other hikers.

"So many folks are surprised to see a cat on the trail or think it's strange to see a cat on a leash," she says. "For me, it's great to watch the stereotypes of cats break away when you can speak with others about the joys of adventuring with your cat."

"It's great to watch the stereotypes of cats break away when you can speak with others about the joys of adventuring with your cat."

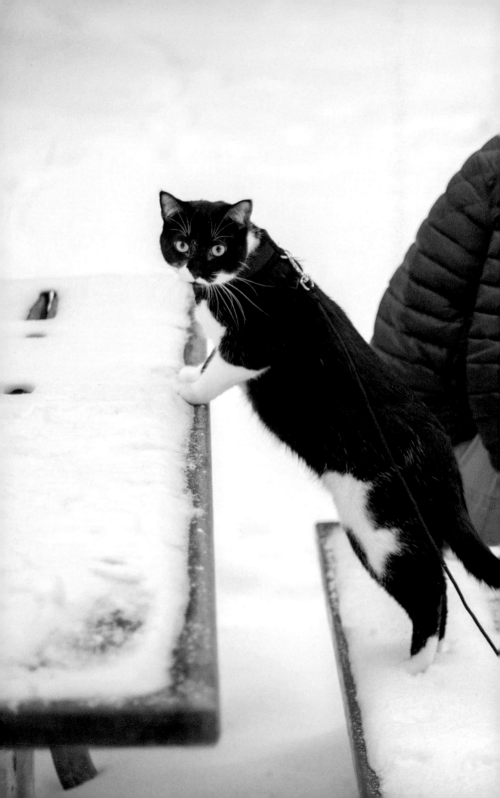

CATS IN THE NEIGHBORHOOD

ADVENTURES CLOSE TO HOME

>»»»» «««««

EXPLORING THE CONCRETE JUNGLE

STREETWISE SMARTS FOR CITY KITTIES

MEET BELA, THE BROOKLYN ADVENTURER

BRING THE ADVENTURE INSIDE

CATIOS: PATIOS FOR CATS

TAKE KITTY FOR A STROLL

EXPLORING THE CONCRETE JUNGLE

Not every cat has a backyard wilderness to explore, but apartment kitties and those who live in more urban environments can still enjoy a little outdoor leash time. Sometimes this means helping a feline adjust to sidewalk strolls or transporting your cat to a nearby park so she can feel the grass beneath her paws.

"My cat Knox is not one for sitting still, but there's only so much playing and running around you can do in a small New York City apartment," says Heather York. "I initially laughed at the idea of buying a leash for my cat. It just seemed so silly. Then I realized New York would be the perfect place to do it."

Once Knox was comfortable on his leash, York began looking for suitable green spaces she could take him to, which she admits was difficult in such a bustling city. "The disadvantage to urban adventuring is that there are few parks and grassy areas. It's also heavily populated, so [finding] a quiet area can be difficult. But Knox loves to explore and truly enjoys the fresh air," she says. Luckily, York was able to find parks that fit their needs, and now the pair often strolls along the Hudson River or lounges in quiet parts of Central Park.

New York City's parks provide Knox with ample adventure opportunities.

Who says city cats have to stay indoors?

But, depending on the cat, a quiet, unpopulated place isn't always necessary. Gandalf, a deaf Cornish Rex who lives in Brisbane, Australia, explores both nature preserves and city streets with equal curiosity. "He is totally unfazed by people and crowds and just likes to go about doing his own thing," says his owner, Martin Henrion. "He totally ignores people when they pat him and keeps walking, which I'm forever apologizing for." The fact that Gandalf can't hear all the city noises, Henrion notes, may be part of the reason he's so unaffected by the lively atmosphere.

However, Albie, an adventure cat in Portland, Oregon, can hear just fine, and she's also comfortable both on the street and on the trail. "I kept things pretty local at first on quiet streets by the house, but now we go on hikes and she sits in my backpack and then explores when we get to our destination," Albie's owner, Melissa Capone, says. "In Portland, we do have the best of both worlds because we can spend one minute downtown in the middle of it all and the next on a peaceful walk on the trails."

STREETWISE SMARTS FOR CITY KITTIES

Use the Space You Have

You don't need a large area to give your cat a taste of the outdoors. Visits to your courtyard or rooftop garden can suffice—just keep your kitty away from the ledge. "Being in a city, we had to be creative with where to take Chickpea," says Brooklyn resident Nate Hunter, who walks his Maine coon on a leash. "We didn't like the idea of bringing her onto the street because we thought she might get scared of all the noise and people walking their dogs. We have access to our apartment roof, so we decided to start her outdoor journey there. Besides the roof, we like to take her to the various parks throughout Brooklyn. The first day we took her to our local park, we got a few funny looks and a couple of dogs barked at her, but Chickpea absolutely loved being outside." If you have a balcony or porch, screen it in, or convert it into a catio (see page 192) so your cat can safely enjoy the view. You may also want to consider purchasing a screened-in pop-up tent for your cat, which can fit in even small outdoor spaces such as an apartment balcony.

Chickpea enjoys walks in Brooklyn's Prospect Park.

Do Some Location Scouting

If you're looking for a larger area to explore, visit local parks or green spaces without your cat at first. Look for quiet areas that don't get a lot of foot traffic, and visit at different times of the day to get a feel

for when the park is busiest. "Find a quieter park area that doesn't have a lot of kids or dogs running around so your cat is less likely to be spooked," says New York City resident Catie Savage who takes her cats, Ziggy and Lambchop, outside on leashes. Also, check the routes and types of

Even in the busiest cities, it's possible to find quiet green space in public parks.

transportation that you would need to get your cat to the area—the perfect park may not be quite so perfect if it requires long bus rides or multiple train changes.

Check the Sidewalk

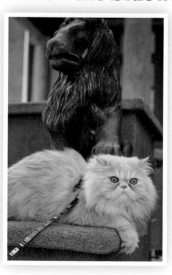

Your kitty may be comfortable walking the blocks of your neighborhood, but be sure to scout the area and pay close attention to where you're walking. Sidewalks can be littered with trash, broken glass, and even substances like ethylene glycol, the primary ingredient in antifreeze, which can be deadly to cats if they lick it off their paws. Make sure your path is clear before taking your cat outside, and avoid any substances you can't identify.

Be Wary of Noise

Cats' ears are very sensitive to sound—they can hear even better than dogs—so be wary of walking in noisy areas where your cat may become frightened. "There have been a few times when something has spooked Bela and I've had to quickly pick her up and take her inside," says Andrea Rice

Bela sticks to her Brooklyn block when she adventures.

who walks her cat, Bela, around their Brooklyn block. "She's quite strong and very fast, so I have to pay attention to her at all times."

Watch for Dogs

Parks, sidewalks, and building courtyards are all places you're likely to encounter dogs, so try to avoid areas with lots of canines—especially unleashed ones—and always keep an eye on your surroundings. "Portland is very pet-friendly, which is great, but we had an incident with a dog owner who didn't have his pup on a leash," says Capone. "Albie got a pretty big scare and this has put me on much higher alert when we are walking in a downtown area. I usually scoop her up when I see any dogs."

While some cats might be afraid of dogs, others have found that dogs make great adventure companions.

MEET BELA, THE BROOKLYN ADVENTURER

*W*alk along the tree-lined residential streets of Crown Heights in New York, and you'll likely spot Bela. The four-year-old black cat ventures out of her Brooklyn apartment every day to walk the block or to simply sit atop the stoop and keep watch on the neighborhood. Rain or shine, Bela insists on her daily adventures. "Being outside is her favorite part of the day," says Andrea Rice, Bela's owner. "When she's indoors, she gazes longingly out the window, as if she's plotting her next walk. It's our special bond."

Rice adopted Bela from a no-kill shelter in 2012. Bela was malnourished, had conjunctivitis, and was the runt of a litter that had been found in a local trash bin. The rest of her brothers and sisters had already been adopted. "It broke my heart that nobody wanted her," Rice says. "When I opened her cage, she jumped into my lap. That's when I knew she was coming home with us."

Bela quickly adjusted to her new home, but she had too much energy for the apartment to contain. She'd run laps around the rooms and jump onto the windowsills. "It didn't take long before I realized she needed to get outside," Rice says. "At the height of Bela's stir-craziness, after a long New York City winter, I bought a cat harness."

Because of her batlike ears, Bela was named after Bela Lugosi, the actor famous for portraying Count Dracula.

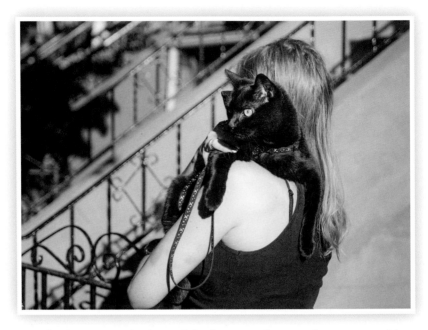

The first time Bela donned the harness, she was about a year old and unaccustomed to wearing anything, so she toppled over. But after a few trips outside and plenty of treats, she learned to associate the harness with outdoor adventure. Now, she purrs when Rice puts it on her. They keep their adventures close to home, however. "The city is a loud and scary place for a little animal," Rice says. "For the most part, Bela is quite brave, but she definitely hates the street sweeper. We don't go far beyond our neighborhood block, since we're surrounded by busy streets."

Luckily, there's plenty for Bela to see and do on her small patch of Brooklyn territory. She explores the sidewalks, climbs trees, watches pigeons, and lounges in the small courtyard near her home. "We sit on the stoop together during the day, and she's pretty much become a

"She's pretty much become a permanent fixture in the neighborhood."

permanent fixture in the neighborhood," Rice says. "People of all walks of life will stop and either remark on how unusual it is to see a cat on a leash in Brooklyn, or admire Bela for being such a beautiful feline. She always puts herself on display, as if she knows she's being admired."

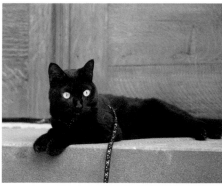

Rice says Bela is "very friendly with strangers who want to pet her, talk to her, gawk at her."

Rice says that her cat's presence in the neighborhood has made her the go-to person for doling out advice on leash training, and she hopes that more people will begin taking their cats outside.

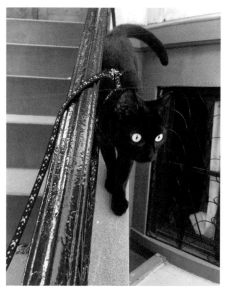

Although Bela doesn't venture too far from home, there's still plenty for her to see and do.

"All cats should be able to have time outdoors in fresh air, every single day," she says. "Last week, on my way to the laundromat, I had a conversation with someone I'd never seen before. He stopped me on the street to tell me how much he likes my cat, how he sees her every day outside, and we had a whole discussion about how important it is for animals to be outside in nature, especially in a place like New York City."

《《

BRING THE ADVENTURE INSIDE

Not all cats are the outdoor-adventuring type, but even indoor-only kitties need to explore. While we may like to think of our cats as snuggly little lap warmers, the truth is they're also predators that aren't that far removed from their wild ancestors. So help your kitty tap into that wild cat within by bringing the adventure inside. It's as simple as enriching your cat's environment and engaging in playtime, which is something you'll both enjoy.

Design a Feline-Friendly Home

Even a simple window ledge can be a source of entertainment for an indoor cat.

Providing plenty of places for your cat to climb, hide, and play will create an environment that encourages an active lifestyle. Cardboard boxes, scratching posts, cat trees, and even furniture positioned at varying levels allow your kitty to embark on indoor adventures all on his own. "Having vertical space is important, both for enrichment and to decrease anxiety," says veterinarian Dr. Jennifer Stokes. "It may be overkill, but I have cat trees in almost every room of my house."

And just because your cat doesn't want to don a harness doesn't mean he can't still enjoy nature from the safety and comfort of the indoors. "You don't really need outdoor space to give your cat an outdoor experience," says pet columnist and author of *Greening Your Pet Care*, Darcy Matheson. "Part of that is creating what I call 'Bird TV'—hanging a birdfeeder or a birdbath outside a window where your

cat can easily see it. You want to make sure your windows are tightly secured and that your cat has a comfy spot to sit in. It's a really easy thing you can do for your cat that doesn't cost a lot of money."

Go "Hunting"

For cats, playtime is all about hunting prey, so the best way to engage your cat in play is to appeal to his natural instincts by simulating a good hunt. Interactive toys like feather wands, laser pointers, and fishing-pole toys are ideal for this, but it's not just the toy that matters—it's how you play with it.

To get your cat's attention and encourage him to stalk and pounce on the toy, it's important to make it act like prey would. Move the toy quickly across the floor away from your cat like a mouse or have it hop around the floor and suddenly fly into the air like a bird. And kitties can't help but chase something that turns the corner and appears to be hiding. Try different types of toys and various actions to see what gets your cat's attention, and be sure to let your kitty catch the prey on occasion. Also, when you're finished playing with an interactive toy like a feather wand, put it out of sight until it's time to play again so the toy maintains its appeal.

Build a Hidey House

You're likely already aware of your cat's love affair with boxes. The reason he loves to climb, hide, and play inside the remnants of your Amazon deliveries is because the confined space acts as protection from predators—as well as an ideal place to watch for prey. Providing a box for playtime is an inexpensive way to let your cat engage in natural behaviors, and you can make that box even more fun by cutting a few holes in the side, sprinkling in catnip, or dropping in a few toys. You can also incorporate your kitty's box into playtime by dangling a feather wand or fishing-pole toy outside the box while your cat hides inside and bats at it through the windows.

Play Fetch

Dogs aren't the only animals that enjoy chasing and retrieving toys. "Many cats can be taught to play fetch, and I think most want to have active interaction with their people," says Dr. Stokes. Lots of indoor cats enjoy a good game of fetch because a toy that flies through the air or rolls along the floor looks a lot like prey. Try tossing a favorite toy across the room to capture your kitty's attention.

Solve a Delicious Puzzle

A great way to keep your kitty mentally stimulated when you're not home is a self-play toy like a puzzle feeder or food-distributor ball, devices that release food when a cat interacts with them. These toys encourage cats to work for their food by batting at them, chasing them, or solving a puzzle, and the food reward they provide motivates cats to play. Just be sure to account for the food in the feeder when determining your cat's daily nutrition allowances.

You can purchase puzzle toys at your local pet store or even make your own with objects you have around the house. A small plastic food container with a lid or even an empty plastic water bottle can easily be transformed into a puzzle toy. Simply cut a few small holes into the container and then add some food and replace the top or lid. Your cat can now chase and bat the container and be rewarded for his efforts when a few tasty morsels fall out.

CATIOS: PATIOS FOR CATS

While most cats are fascinated by the outside world, not all of them can or should venture out on a leash. But with a catio, indoor kitties can safely enjoy a little sun on their fur and wind in their whiskers. Catios are outdoor enclosures designed especially for cats that allow them to experience the sights, scents, and sounds

of nature while keeping them safe from traffic, predators, and other outdoor dangers. And, as an added bonus, they keep the local wildlife safe from your cat too.

A catio is a creative way to satisfy an indoor cat's curiosity about the outdoors.

There are a variety of catios on the market. They may take the form of transportable pop-up tents or small window boxes, but they can also be large, elaborate constructions that feature varying levels, scratching posts, and pet doors that let cats come and go between the house and the catio as they please. Catios can range in price from under a hundred dollars to up to several hundred dollars, and while smaller ones may come fully assembled, larger structures are typically purchased as prefabricated kits or custom built to fit a cat owner's space.

Carol Lin, founder of Tabby James Organic Catnip, says that her cats "lost the sparkle in their eyes" when she moved them inside her home for safety. "I keep them entertained with catnip, toys, and scratchers, but I know that it's not enough," she says. "They love rolling on the grass, basking in sunlight, smelling the myriad scents in the wind." That's when Lin decided to build a catio. However, after assessing the cost and labor that a custom project requires, she turned to prefabricated ones.

If you're considering purchasing or constructing a catio, there are a few things to consider. First, what kind of budget do you have? If you don't have a lot of money to spare, consider a window-box setup, which is commercially available or can be a fairly simple DIY project. A small freestanding catio that snaps together like a temporary outdoor playpen is another option; however, these are

typically made of plastic and netting and should be used under supervision because they don't offer as much protection from weather and other animals. (Plus, you'll have to take your cat outside—on a leash or in a carrier—to help her get into any freestanding structures.) If you're pretty handy, you can also construct your own budget-conscious catio. "You can do eco-friendly

Catios come in all shapes and sizes.

construction that doesn't have to cost a lot of money by using recycled boards from other projects," says pet columnist Darcy Matheson. "You just need some two-by-fours hammered into a frame and covered in wire mesh to keep it secure, and then just build some shelving on the inside."

If you have a larger budget to play with, the only limits to your kitty's dream catio are your imagination, your available space, and any restrictions by local ordinances or homeowner associations. You could build a catio that's directly accessible from your home through a window or door, or you may want to construct a freestanding catio in your yard that's large enough to accommodate a cat tree, as well as patio furniture for yourself so you and your cat can enjoy the catio together. If you're looking for a little "inspurration," check out cat style expert Kate Benjamin's website catioshowcase.com, which is full of gorgeous and innovative catio ideas.

Live in an apartment with only a small balcony? No problem. A pop-up tent or a small stand-alone enclosure can do the trick, or you can transform the entire balcony into an outdoor getaway for your kitty. "You can create a catio even in very small outdoor

spaces," Matheson says, adding that a similar setup can be achieved by enclosing your patio with some finer mesh. "It may be unsightly, but it means your cat is not going to be at risk of falling off your balcony."

Once your catio is complete, introduce your kitty to his special new space at a quiet time. He may be a bit wary at first, especially if he's never been outside, so allow him to explore at his own pace. Place some treats or favorite toys around the catio or give it a good sprinkling of catnip to help your cat make himself at home.

Keep in mind that catios aren't right for every kitty. Some cats may never be comfortable in an outdoor enclosure even if they love watching "cat TV" through the window. Also, some areas—especially those with large predators—simply aren't safe for cats to be outside.

Let your yard grow a little wild— just like your cat.

Create a Cat-Friendly Garden

Make your yard a true playground for your cat by filling it with safe, yummy plants to chew on, leafy nooks to lounge and nap in, and places to scratch. When it comes to creating a garden for your cat, don't worry about keeping it neat and manicured. Tall grass may look unkempt to you, but it's a fun place for your cat to explore, as well as an ideal place to hunker down and watch for insects. Plant some kitty-friendly greenery such as catnip, lemongrass, mint, and wheatgrass, and if you're not sure if a flower, shrub, or other plant is nontoxic, check before you plant it (see a list of common toxic plants on page 88). Also, to keep this garden safe for your kitty, never use pesticides, fertilizers, or other chemicals that could be harmful.

Cats scratch on things (like your furniture) for several reasons, including to mark territory, so don't be surprised if your kitty wants

Create a Catio That's the Cat's Meow

To design the purrfect outdoor paradise for your cat, consider these points:

- Whether you're building your own catio or purchasing one, be sure the enclosure is made of sturdy, nontoxic materials such as metal and pressure-treated wood. Cats are climbers, so you'll want to avoid weak wiring or mesh or any materials that could easily break or rust. Also, make sure the roof of your catio is strong enough to withstand rain and snow.

- The floor can be dirt, sand, grass, or pavement, but keep in mind that some cats may use dirt or sand as a litter box. Cats are also diggers, so you may want to bury mesh beneath the catio if you use dirt or sand.

- If your catio is particularly large or elaborate, include a human-sized door so you can easily get inside to help your cat if he ever requires assistance.

- The inside of a catio should contain a protected, shaded area where your cat can escape from the sun, weather, or any threats.

- Always provide a water bowl and litter box for your cat while he's inside the catio. While it's OK to give your cat some treats in the catio, don't leave food inside, as it could attract curious wildlife.

- Fill any available space in the catio with climbing trees, scratching posts, toys, and some delicious cat-friendly grass to munch on.

 - Always supervise your cat when he's in the catio, and if he'll be outside at night, add lights to the catio so you can keep an eye on him.

to mark your yard as belonging to the king or queen of the house. To protect your trees, place a small log in your garden or install one vertically and encourage your cat to scratch there. You can even wrap the log with sisal rope. Stumps or pieces of wood of varying heights can also be safe places for cats to climb and survey their surroundings. After all, cats love to climb, but scaling a tree or other tall object while on a leash isn't safe because the leash could easily become tangled or snag on a branch.

While cats love to lounge in the sunshine, they need places to cool down, too, so be sure to provide some shade in your garden. Large, leafy plants may be all you need, but you can also provide other sorts of shelter like a small umbrella.

It's a good idea to supply a dirt or sand area as well, for your cat to do her business. Some cats may prefer the familiarity of the litter box and never relieve themselves outside, but it doesn't hurt to be prepared. And remember that cats tend to urinate and defecate in the same place, so if you don't want your cat going in the garden, be sure to keep this area away from the plants.

Finally, no kitty playground is complete without toys, so bring out a few of your cat's favorites for her to pounce on and chase. You can also tie feathers or other toys to low-hanging branches for your kitty to bat at—better the toys than the local wildlife.

TAKE KITTY FOR A STROLL

Falling somewhere between leash walking and lounging in a catio or garden is a third way to take your cat outside: in a stroller. Pet strollers are very similar to strollers designed for human infants—however, they feature zipped enclosures so your fur baby can view the world through mesh windows. They vary in both size and cost, but most strollers are designed to accommodate one cat and run around $50 to $200.

"George's leash training is a work in progress," says Brooklyn resident Tina Ferraioli. "He recently got a set of wheels though, so I have been working on getting him more comfortable with the outdoors in our local park. It definitely draws a lot of attention." Some cat owners say such attention can be a downside to stroller walking; however, the benefits to the cat typically outweigh the occasional negative comment. Cats that take regular stroller rides get the same mental stimulation as leash-walked cats, and stroller rides can be an especially rewarding activity for handicapped cats or older felines with mobility issues.

A pet stroller can be a fun alternative to leash walking.

"I got a stroller because it provides Simon with a safe place when something makes him nervous," says Dr. Stokes. "I can also take him to more crowded places like the local farmers' market, pet-friendly stores, etc. We go to a local park and I can push the stroller on grass without too much trouble if it is a

flat surface. I actually never walk him without it. We even did a 5K together."

Think your kitty would enjoy a stroller? Take him for a test drive to find out and see how he reacts. "All of our cats who are not human fearful get tested for stroller rides," said Michelle Warfle, manager of Best Friends Animal Society's Cat World, which is home to more than seven hundred free-roaming, adoptable cats—one hundred of which enjoy regular stroller rides. "We assess how the cat is sitting in the stroller. If they don't get stressed and seem to enjoy the experience, they go on an approved list for stroller rides. Cats who don't like to walk far on a harness seem to love stroller rides. It gets the cat outdoors to exercise all their senses on new things. Given that we are a sanctuary and many of our cats will live the remainder of their lives here, enrichment is critical to ensuring quality of life."

DEFYING THE ODDS

CATS WHO OVERCAME DISABILITY TO EXPLORE THE GREAT OUTDOORS

>»»»»› ‹«««««‹

CAN DISABLED CATS HAVE OUTDOOR ADVENTURES?

🐾 MEET STEVIE, THE CAT WHO DOESN'T NEED SIGHT TO ENJOY THE GREAT OUTDOORS

🐾 MEET ZHIRO—SHE CAN'T JUMP, BUT SHE CAN CLIMB

>>>

CAN DISABLED CATS HAVE OUTDOOR ADVENTURES?

Some of the most inspiring, fearless felines are those who hike, camp, and explore the world despite their disabilities, proving that nothing can keep an adventure cat from living nine lives to the fullest. From blind and deaf cats who climb mountains with their owners to cats with mobility issues who require a stroller to enjoy the local scenery (see page 198 for more on strollers), these heroic felines prove that there's no reason your cat can't have an outdoor adventure as long as you practice caution.

"As far as Gandalf is concerned, being deaf is no impairment whatsoever," says Martin Henrion, about his Cornish Rex who has been deaf since birth. "If anything, it has made him more fearless, which is another challenge for me to manage as an owner." Gandalf loves to take leashed walks and explores both the streets and wilds of Brisbane, Australia. "He wants to go anywhere and everywhere—markets, shops, parks, picnics, friends' houses, forests—you name it. He craves adventure, and I often wonder if his insatiable appetite for the outdoors is in part due to his deafness, in that he looks for stimulation from his other senses, which the great outdoors provides in a near endless quantity."

Dr. Amy Holford says deaf cats typically do well on walks because they're not easily spooked, and she simply recommends that owners serve as the cats' ears to

This Cornish Rex might be deaf, but that doesn't stop him from enjoying the great outdoors.

keep them safe. However, taking a blind cat outside requires a bit more caution. "A Muffin's Halo (a device made of lightweight tubing that encircles an animal's head) may be helpful to keep them from banging into unfamiliar objects," she says. "Owners will need to be their cat's eyes and take into account curbs, bushes, trees, cars, etc." Patrick Corr, who hikes with his blind cat, Stevie, says that's exactly what he does, and to ensure the path is clear, Stevie has even learned to follow him.

Zhiro doesn't let her neurological disorder stop her from exploring.

Lacy Taylor, whose cat Zhiro has a neurological disorder, says that outdoor excursions aren't only enjoyable for her fluffy, two-year-old cat, but they've also helped Zhiro overcome some of the physical challenges of her condition, including her wobbly gait. Going for walks can also be beneficial for felines with problems such as Manx syndrome. Cats with Manx carry the gene for shortened tails, but sometimes the gene affects a cat's entire back, preventing the spinal cord, organs, and muscles from developing properly. Taking long outdoor walks was one way that Marcus, a Manx at Best Friends Animal Society in Kanab, Utah, was able to ease his back pain.

Whether your cat is blind, deaf, or has another type of disability, don't assume that he can't join the ranks of adventure cats. After all, venturing into the great outdoors is more about personality than ability. "I am sure there are deaf cats out there whose underlying personalities don't marry up with the adventure-cat lifestyle, but in my experience, it's unlikely to be due to deafness," says Henrion.

It's best to talk to your veterinarian first though to ensure that your kitty is in good condition for a little outdoor exploration. Every cat is different, and while some may be able to adventure despite a disability, others may not. "Zhiro's is a mild case [of cerebellar hypoplasia], and I know in some of the more severe cases, cats can't even walk," says Taylor. "However, Zhiro's condition is not severe and she seems happy exploring with us."

Also, take Stokes's advice and keep a watchful eye on your surroundings when outdoors with a cat who may not be able to see, hear, or get around as easily as most felines. "A huge—somewhat irrational because we're so careful—fear of mine is losing Gandalf, as he is very adventurous but obviously can't be called and is often unaware of the dangers of the environment," says Henrion. "So I always keep him on the leash or in my sight when outside, and we never leave doors or windows open at home when inside. So you do have to be that little bit extra careful all the time."

Still, don't underestimate your kitty. If you have a cat with a disability, you've likely witnessed their impressive ability to adapt. Gandalf uses vibrations to sense when people or other animals are nearby. Stevie the blind cat who hikes with her owner in Ireland—keeps her head low so she can use her whiskers to detect her surroundings.

And keep in mind that what may seem like a disability to you could actually be beneficial to your cat. "It's quite funny to watch smaller yappy dogs bark at Gandalf on approach and then slowly quiet down and hide behind their owners once they see their bark has absolutely no effect on him," Henrion says.

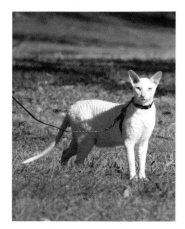

Gandalf is impervious to dog barks and other startling noises.

MEET STEVIE, THE CAT WHO DOESN'T NEED SIGHT TO ENJOY THE GREAT OUTDOORS

*W*hen Irish filmmaker Patrick Corr saw a photo of a blind shelter cat named Stevie he knew he had to meet her. "On Facebook, I came across the story about Stevie and how she badly needed a home, and I couldn't resist. As soon as I met her, she instantly purred in my arms, and I had to bring her home."

Corr says it took a lot of planning to prepare his apartment for a blind cat. He was determined to make Stevie's transition to post-shelter life as seamless as possible, because he knew that once she arrived, he couldn't do any rearranging. "One of the most important factors to consider with a blind cat is that they need to map out where everything is," he says. "It takes them time to get used to navigating a new area, so you need to avoid moving anything—that includes furniture, litter trays, everything. Eventually everything becomes so familiar that you almost forget they're blind at all."

Stevie quickly learned her way around her forever home, and in the process, she discovered her favorite part of the apartment: the porch. She was determined to spend all her time there, taking in the

sounds and smells of nature, but Corr wasn't sure about taking the next step beyond the porch. He was concerned that being outside wasn't safe, especially since Stevie couldn't see any approaching threats. "I was worried that she would be vulnerable outdoors, but that's when I decided to use a harness," he says. He began leash training Stevie indoors, and once she was ready, he took her outside. "It started with the porch, then moved on to the courtyard beside my apartment, and eventually on to the local park, and so on, going a little farther each time." It took months for Stevie to be comfortable walking out in public, where the sounds and sensations can be overwhelming, but she enjoyed being outdoors and eventually became accustomed to the experience.

The more they adventured together, the more Corr realized that a lack of vision certainly wasn't holding Stevie back. In fact, she'd found ways to compensate for her blindness. "When Stevie is out exploring the world with me, her other senses kick in," he says.

"When she's outside she keeps her head low so her whiskers can detect objects in her path. She often follows the sounds of my footsteps to know it's safe to keep walking in that direction, but otherwise, she's incredible at navigating on her own. Stevie really showed me that anything is possible if you put your mind to it."

"Stevie really showed me that anything is possible if you put your mind to it."

Stevie had years of leash walking under her collar before she attempted her first hike, but after seeing how much she enjoyed hiking, Corr had no qualms about attempting their biggest hike yet: climbing Carrauntoohil, the tallest mountain in Ireland. The feline-friendly hiking trip was organized as part of a fundraiser for two Irish animal shelters, and together, Corr and Stevie raised more than two

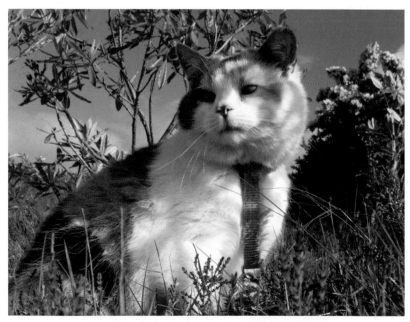

Stevie is named after blind musician Stevie Wonder.

thousand dollars for the rescue organizations—and had a great time doing it, which Corr captured in a short film.

"Animal shelters in Ireland—and indeed all around the world—are inundated with new animal rescues every

Corr says, "Stevie never lets anything stop her, and that's something I really admire about her."

day, many of them constantly struggling with expensive vet bills for procedures that range from simple vaccinations to life-threatening emergencies," Corr says. "I wanted to give something back to the people who make it their life's work saving animals in need just like Stevie."

In addition to helping him raise thousands of dollars and bringing joy to his life, Corr says that Stevie has also taught him an important lesson. "Animals see the world in very simple terms, and that can really put things into perspective for humans, especially for someone like me who likes to overthink things. When Stevie bumps into something in her way, she simply shakes her head and continues—the simplicity in this act is quite inspirational to me. There are plenty of times in life when you hit barriers both personally and professionally, but you can't simply stop and spend time worrying about it. You have to just pick yourself up and move on."

And while you may think that Corr saved Stevie, he says it's actually the other way around. "I adopted Stevie during a rough time in my life, but getting the chance to care for her taught me a lot about self-worth when I needed it the most, and it helped build me up to become a much stronger person. Sometimes saving an animal's life can end up saving you as well, especially when you least expect it."

MEET ZHIRO— SHE CAN'T JUMP, BUT SHE CAN CLIMB

When Lacy Taylor left her Utah home for a morning run two years ago, she heard a strange sound coming from beneath her house: muffled crying. She grabbed a flashlight and followed the sound, finally spotting a small white kitten several feet out of reach. It took numerous attempts to coax the timid feline out, but soon the kitten was in Taylor's arms, and had found her forever home.

Taylor's boyfriend named the tiny kitten Zhiro, after an obscure *Star Wars* character, and after about a week, Zhiro was perfectly comfortable with her new family. But as Taylor and her boyfriend watched their fur baby explore their home, they realized that something was off. Unlike their other cats, Zhiro wobbled when she walked, and it was especially noticeable when she ran.

"We thought it was cute at first and attributed it to her being young and just getting her bearings on a carpeted surface," Taylor says. "The wobbling did not go away after the first week, however, and whenever she took a sharp turn she would stumble and fall. When we got her into her first veterinary appointment and explained what we had observed, the vet said she had an idea of what it could be and brought out some food. When Zhiro went to eat the food, her head kind of jerked around. That's when the doctor diagnosed her with cerebellar hypoplasia."

Zhiro finds the perfect nook while exploring a rockface in Moe's Valley, Utah.

Cerebellar hypoplasia is a neurological condition that occurs when parts of the cerebellum don't develop completely, causing walking and balance problems. Zhiro's case is mild, which makes her occasionally wobble when she walks and prevents her from jumping and leaping like most cats. But other than that, she's perfectly healthy. "Once we found out she had cerebellar hypoplasia, we talked extensively with our vet about what we should expect from her moving forward," Taylor says. "We were assured she was not in any pain because she had a brain issue—not a skeletal one. The vet told us this condition is commonly misdiagnosed and cats are euthanized because it appears they are in pain."

Once they were aware of Zhiro's condition, Taylor and her boyfriend made some simple adjustments around the house to ensure Zhiro was comfortable, like setting up steps beside the bed. "She has real trouble with jumping. She can jump short distances, but not

Zhiro sometimes gets a ride to the crag on a bouldering crash pad.

even half the distance of my other cats. She usually has to pull herself up onto things," Taylor says.

But her condition didn't slow Zhiro down, and when Taylor and her boyfriend—who are both avid climbers—put the six-month-old kitty in a harness, she took to

"Her wobbly walk has almost disappeared, which I attribute to the fact that we keep her active either outside with us or inside playing with my other cats."

it immediately. "We noticed how eager she was to go outside when every time we came home, she would be waiting at the door. Since we were going to California for Christmas, we decided to bring her along. While we were there, we wanted to boulder for a bit, and we decided to see if Zhiro would cooperate and come with us. To our surprise, she was eager to walk around and explore everything. However, she was not too keen on sticking to the trail. We eventually decided to carry her toward the end of our hike and shortly discovered her preferred mode of transportation was hanging out on top of our crash pads."

Since then, Zhiro has accompanied her humans on countless hiking, climbing, and camping trips, and Taylor thinks her adventure kitty's active lifestyle has helped keep her healthy. "Her wobbly walk has almost disappeared, which I attribute to the fact that we keep her active either outside with us or inside playing with my other cats. We do, however, always know if there is a bug or somebody approaching because her head will do this sort of jolted scanning motion repetitively while she is trying to focus her gaze. She doesn't appear to be fazed by anything though. She has taken us on hikes recently, pulling us up the mountain trails."

To ensure Zhiro stays safe, Taylor says they always keep her leash on, and they're careful to avoid climbing areas that are popular with

dog owners. And if it's hot outside, Zhiro has to sit the adventure out. When she does get to tag along though, Taylor says she's always armed with a litter box, extra water, cat food, and a can of tuna. "It is really hard to tell what cats are thinking or wanting at times, so I am always checking on her to make sure she is comfortable throughout the day with water, food, shade, and so on. I continually check her paw pads and nose to make sure she is not overheating."

As for Zhiro's cerebellar hypoplasia, it's hardly a factor these days. "We can tell that Zhiro gets very antsy in the summertime when we don't bring her out on our weekend adventures, so we give her some outdoor time before work and at night when it is cooler outside. That assures us that she actually enjoys an adventurous outdoor life," Taylor says. "Because of Zhiro's disorder, we were told she would not be able to jump, but instead she would be a climber. We knew she would be the perfect fit for us, since we identify as climbers ourselves."

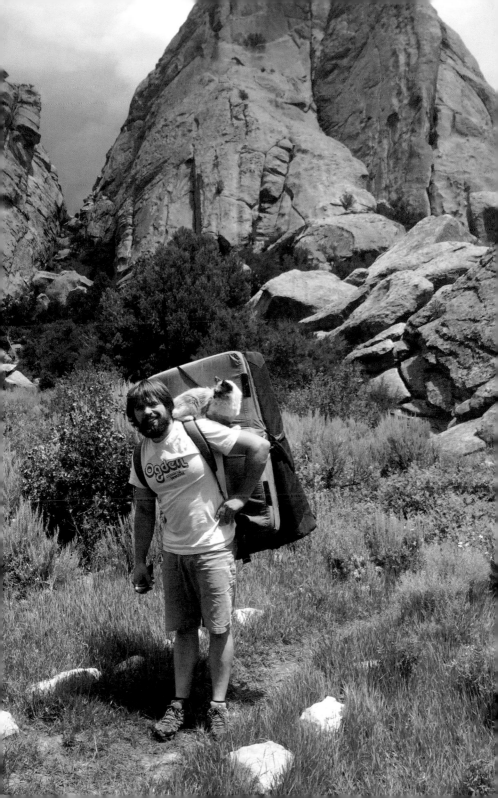

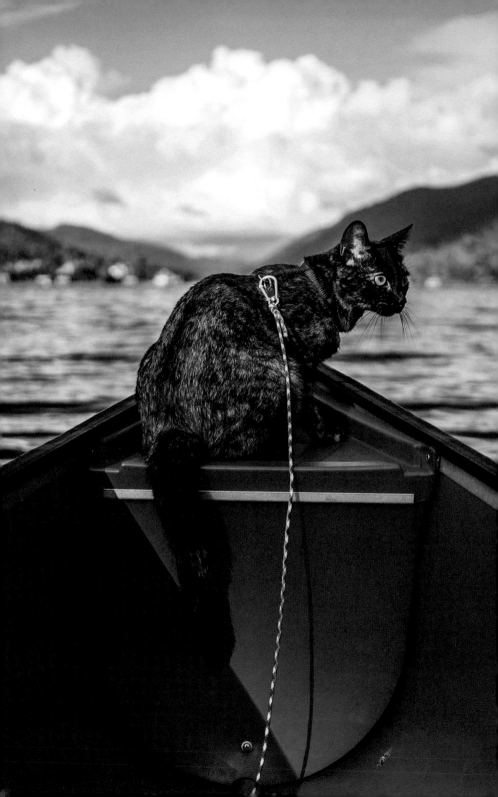

RESOURCES

Where to Adopt Your New Feline Friend

While not all shelter cats want a life of adventure, they all need a loving home. Check out the organizations below to find the newest addition to your family.

PETFINDER
PetFinder.com
This searchable database features adoptable animals from nearly 14,000 animal shelters and adoption organizations across the United States, Canada, and Mexico.

ADOPT-A-PET
AdoptaPet.com
The largest nonprofit pet-adoption website, Adopt-a-Pet works with more than 13,600 animal shelters, humane societies, SPCAs, pet rescue groups, and adoption agencies.

BEST FRIENDS ANIMAL SOCIETY
BestFriends.org/adopt
Best Friends Animal Society runs the nation's largest no-kill animal sanctuary. Visit the organization's website to adopt from its sanctuary or from one of its 17,000 network partners across the United States.

AMERICAN SOCIETY FOR THE PREVENTION OF CRUELTY TO ANIMALS
ASPCA.org/adopt-pet
Visit the ASPCA's website to find an animal shelter or rescue group in your area.

THE SHELTER PET PROJECT
TheShelterPetProject.org
The Humane Society of the United States teamed up with Maddie's Fund to create this site to help potential adopters find a cat or dog in their area.

How to Help Stray and Feral Cats

If you have free-roaming stray or feral cats in your neighborhood, there are ways you can help them, whether it's providing food and shelter or getting involved with trap-neuter-return—a humane method to control free-roaming cat populations. Visit the websites below to learn how you can help your community kitties.

ALLEY CAT ALLIES

AlleyCat.org

This nonprofit advocacy organization works to protect and improve the lives of feral and stray cats.

BEST FRIENDS ANIMAL SOCIETY

BestFriends.org

The Best Friends Community Cat Programs Handbook features everything from managing a cat colony to proper trapping techniques.

Follow the Adventure Cats on Instagram!

Eevee: @whiskered_away
Vladimir: @ourvieadventures
Bolt and Keel: @boltandkeel
Floyd: @floydthelion
Shade and Simba:
 @shadethecat00
 @simbathecat00
Millie: @pechanga
Yoshi: @yoshiandco
Quandary: @exploration_cat

Kiva and Kleo: @kurious.katz
Nanakuli: @kulithesurfingcat
Georgie:
 @mattandjessicasailing
Jesper: @jesperpusen
Ruger: @yooperpaws
Bela: @doctordrea
Stevie: @mrpatrickcorr
Zhiro: @lacyloutaylor

ACKNOWLEDGMENTS

There are so many people who deserve thanks for helping me create this book, so if I inadvertently overlook someone, just know that I owe you a kitten.

To all the adventure cat owners who shared their experiences, photos, and time with me, thank you, thank you, thank you. I have no doubt that the love you have for your courageous kitties will inspire countless people to rescue an animal and save a life.

To my amazing agent, Myrsini Stephanides, who had a vision for this book long before I ever considered writing it, thank you for believing in *Adventure Cats* and for being one of the most badass cat ladies I've ever met.

To my "meownificent" editors, Liz Davis and Evan Griffith, who brought this book to life in a matter of months, thank you for your enthusiasm, for your hours upon hours of hard work, and for helping me find the purrfect balance between too few cat puns and pawsitively too many cat puns. And to everyone at Workman who contributed to this book—from design and production to marketing and sales—thank you for your time and your creativity.

To the talented and inspiring women of Twitterbloc—especially China DeSpain, Corey Wright, Debbie Burns, Lina Ingram, Liza Kane, Melissa Veres, and Nicole Milliken—thank you for your ongoing support, your critiques, and your beautiful words. From India to the Gentle Nest, I'm so blessed to have you in my life and so lucky to get to read your stories before the rest of the world does.

To the Adventure Cats team, especially Jamie Brooks (my partner in crime and cat lady-ness), Kristen Bobst, Anna Norris, and Liz Cox, thank you for pledging your time and talents to this project when I came to you and said, "So I've got this idea for a cat website . . ."

To all of my friends and family who fostered a love of reading, an appreciation of the great outdoors, and a respect for all living

creatures, thank you. Dad, thanks for the weekend hiking trips. Mom, thank you for the summers at camp and for giving in to fifteen years of begging and letting me adopt a kitten. And to my brothers, thanks for all that brand-new camping gear you left in the attic.

Thank you x 10,000 toothpastes to my incredible and supportive husband, Cody Wellons, with whom I get to share all of life's adventures. You sparked the idea for *Adventure Cats* and believed in it from the very beginning, and without your vision, talent, and hard work, it would not exist.

And, of course, thanks to my own furry companions—feline and canine alike—whose sense of adventure helped inspire this book and whose inescapable lap snuggles ensured that I sat down to write it.

Finally, thanks to everyone who's ever adopted a shelter cat, volunteered with a rescue, or donated their time, skills, or money to saving the lives of the millions of felines in the world without homes. Because of people like you, we will save them all.

ABOUT THE AUTHOR

Laura J. Moss is the cofounder of AdventureCats.org—the first and only online resource for information on safely exploring the great outdoors with your feline friend. In addition to being a mom to three rescue animals, Laura is also a journalist whose work has appeared on CNN, the Huffington Post, *Forbes*, Yahoo, and *Best Friends* magazine. She spent six years as a senior editor for the Mother Nature Network, where she primarily wrote about pets and animals—but mostly cats.